荷風蘭韻

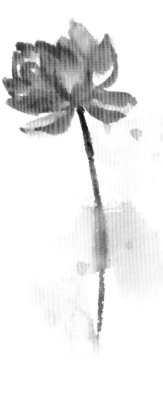

Lotus Breeze
Orchid Melody

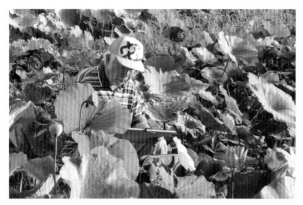

李超倫／攝影

作者序

源自寫生

我畫荷花有五個誘因。

一、早期畫荷花，都是水墨畫家在畫，墨色多，彩色少，雖有其韻味，但
　　總覺得與實際景色不符。

二、後來有人以水彩畫荷花，彩色豐富了，但多以渲染為主，簡單幾筆，
　　有人覺得有靈氣，有人覺得太簡陋。我覺得應該盡量發揮水彩寫實的
　　功能，使水彩技巧充分發揮。

三、有人在荷花池邊寫生，採照相取景方式，畫得很逼真，過分逼真則有
　　失生動，這種畫法，我覺得也不可取。

四、有人用油彩顏料畫荷花，很厚重，不靈活，不是合適的媒材。

五、我退休後，住在埔里岳父的別墅裡，庭園有個大荷塘，近水樓台，天
　　天看荷，天天畫荷。

　　開始我曾用宣紙畫，埔里是宣紙的故鄉，廣興紙寮研發的新紙常要我
試用，宣紙優點是有渲染韻味，缺點是顏色透到背面，正面彩度嚴重受
損，效果不佳。所以宣紙只能是水墨畫的專用紙。

　　現在一般水彩畫家用的水彩紙都是歐洲進口的，大半手工製品，有各
種厚度，這種紙最大的好處是絕不吃色，剛畫和乾後完全一樣，所以數十

年來，我一直用這種紙畫荷花（詳細說明請參閱第70頁拙作「我畫荷花」一文）。畫了很多年，我一直覺得還沒有達到理想，腦子裡總是有一個迷濛又真實，柔軟又挺拔，深遠又壯闊的影像畫面在縈繞著，我想總有那麼一天，我會把它具體呈現出來。

　　畫蘭花似乎更是水墨畫家的專利，尤其是畫國蘭，其流暢生動的姿態、油畫筆、水彩筆都無法相比。但是畫洋蘭，如石斛蘭、萬代蘭、蝴蝶蘭、嘉德麗雅蘭，花以彩色取勝，這一點水彩就絕對佔上風了。所以這些年我畫了很多蘭花，自己覺得效果不錯。

　　我畫水彩已畫了幾十年，一直很注意台灣水彩畫一步一步的變化。目前大體可以分為兩類，一是細膩寫實，一是簡化寫實。細膩寫實的優點是畫面具有相當的質感和量感，充分展現了畫家的耐力、毅力和功力。缺點是有人畫得太像照片，失掉了繪畫應有的藝術性。簡化寫實的畫家，作品多是寫生或由寫生轉化而來。戶外寫生，因受環境影響，不得不簡化，其實巧妙的簡化，正是藝術追求的重要條件。我畫荷花和蘭花，都是源自寫生，面對著活生生的東西，似乎很容易就會把它畫得生氣蓬勃，強韌有力。

Inspired by Nature _____ Sun Shao-Ying

There are five incentives for me to paint the lotus.

In early days, all the lotus paintings had been done by ink painters, which concern more about ink gradation than colors. These paintings might be poetic, but I always feel that they don't resemble the real scenes.

Later on, some people have started to paint the lotus in watercolor, giving more color variations, but they mostly exploit the rendering effect by a few simple strokes, either judged as spiritual or too crude. In my opinion, the realistic function of watercolor should be brought into full play, completely exploiting the watercolor technique.

Some people paint from nature by the lotus pond, adopting the method of photographic view, creating verisimilitude. Yet, over-realism sacrifices vividness, so I do not agree with this method, either.

Some people use oil colors to paint the lotus, but the paintings look very heavy and inflexible. It is not a suitable medium.

After my retirement, I have lived in the villa of my father-in-law in Puli. There is a big lotus pond in the garden. Thanks to my favorable location, I watch and paint the lotus every day.

At the beginning, I once used rice paper to paint, since Puli is the hometown of rice paper. Guangxing Paper Mill often asks me to try out their newly developed paper. The virtue of rice paper is the poetic rendering effect, but it can be faulty to severely ruin the chroma at the obverse side because colors would penetrate through the reverse. It becomes ineffective. Therefore, rice paper can only be solely used for ink painting.

Nowadays, general watercolor artists use Europe-imported paper, mostly hand-made in various thicknesses. The biggest advantage of this kind of paper is sustainable coloring.

The dried work looks exactly the same with the one just painted. Therefore, over the years, I have always used this kind of paper to paint the lotus. (Please refer to my article, page 74 "My Lotus Paintings," for more details.) After many years of painting the lotus, I still feel that I haven't reached my ideal state yet. In my mind, there is always a blurred yet real, soft yet upstanding, and profound yet magnificent pictorial image hovering around. There will definitely be a day that I am able to concretely demonstrate it.

Painting the orchid seems even more like a monopoly of ink artists, especially Cymbidium whose flowing, vivid manners are unsatisfactorily depicted by oil-painting or watercolor brushes. But for depicting the orchid flowers of western origin that are colorfully distinctive, such as Dendrobium, Vanda, Phalaenopsis and Cattleya, watercolor will definitely be more advantageous. Therefore, in recent years, I have done a lot of orchid paintings to my liking.

I have already worked on watercolor for several decades, always paying attention to the gradual development of Taiwan's watercolor art. Presently in general, it can be divided into two categories: subtle realism and simplified realism. The merit of subtle realism is that the pictures possess a certain degree of quality and volume, fully exemplifying the artists' patience, perseverance and talent, but the demerit would be that artistic quality of painting might be lost if the pictures look as lifelike as photographs. The artists of simplified realism mostly paint from nature or transfer their works from sketches. The outdoor painting has to be simplified because of environmental factors. Yet in fact, ingenious simplification is exactly an essential requirement for artistic pursuit. All my lotus and orchid paintings have originated from nature painting. It seems easier to paint a spirited, vigorous picture when I face real living things.

Contents

目錄

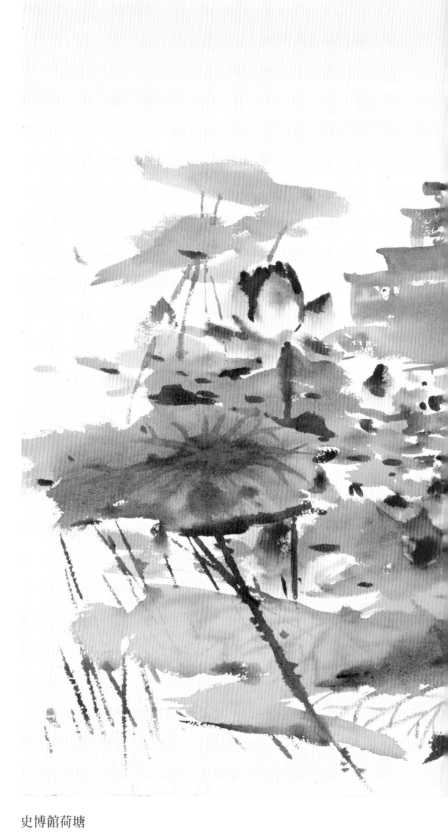

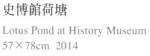

史博館荷塘
Lotus Pond at History Museum
57×78cm 2014

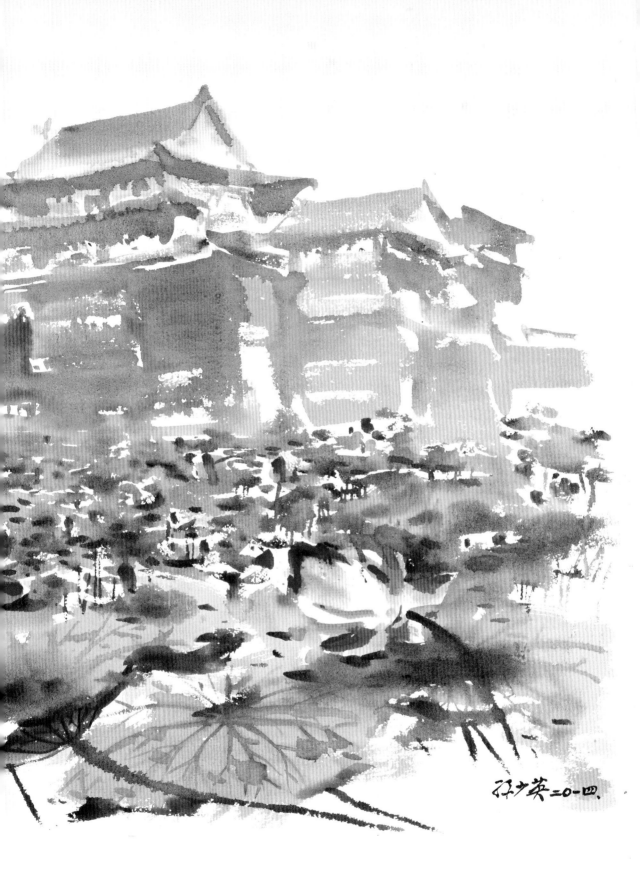

孫少英 二〇一四.

今生今世
Forever Love
78×57cm 2014

採蓮曲

荷葉羅裙一色裁，
芙蓉向臉兩邊開。
亂入池中看不見，
聞歌始覺有人來。

王昌齡

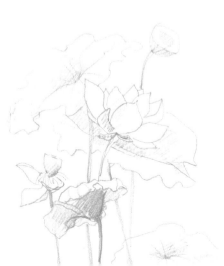

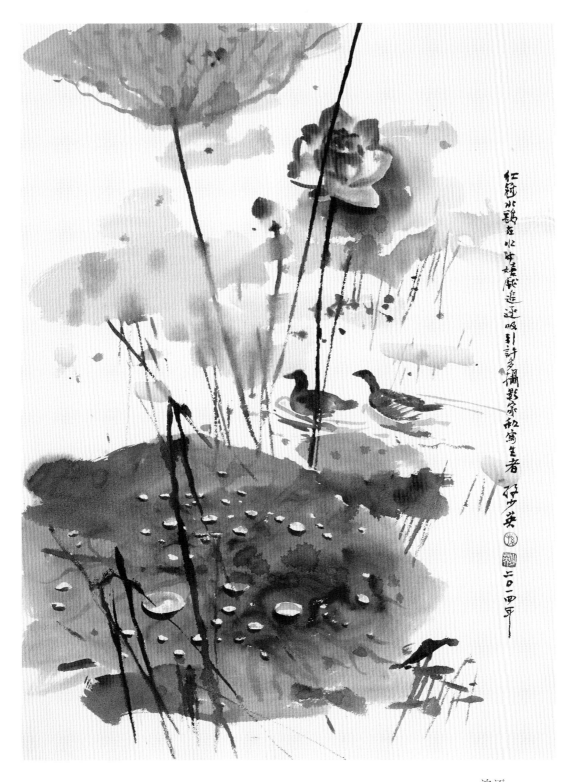

紅冠水雞在水中嬉戲追逐吸引許多攝影家和寫生者 孫少英 二〇一四年

追逐
Chasing
78×57cm 2014

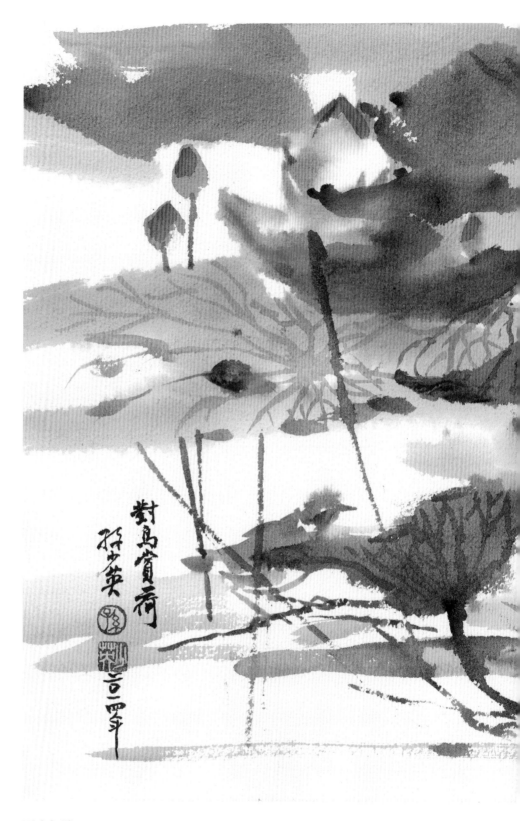

兩小無猜

Playmate

39×57cm 2014

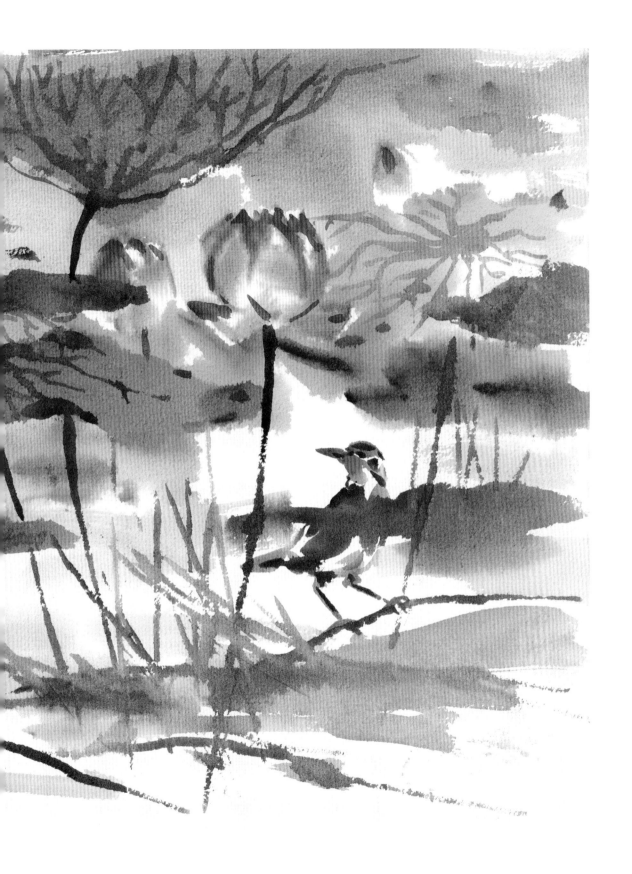

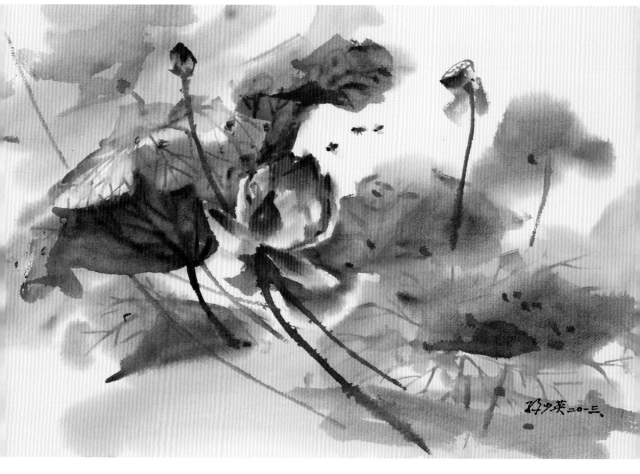

荷花與蜂群
Lotus and Bee
39×57cm 2013

曲池荷

浮香繞曲岸，
圓形覆華池。
常恐秋風早，
飄零君不知。

　　　　　　盧照鄰

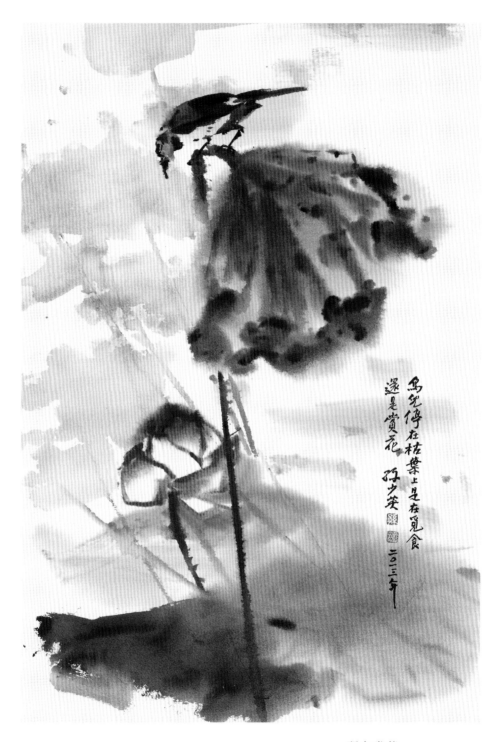

鳥兒停在枯葉上是在覓食
還是賞花 孫少菱 二〇一三年

翠鳥賞荷
Enjoying
57×39cm 2013

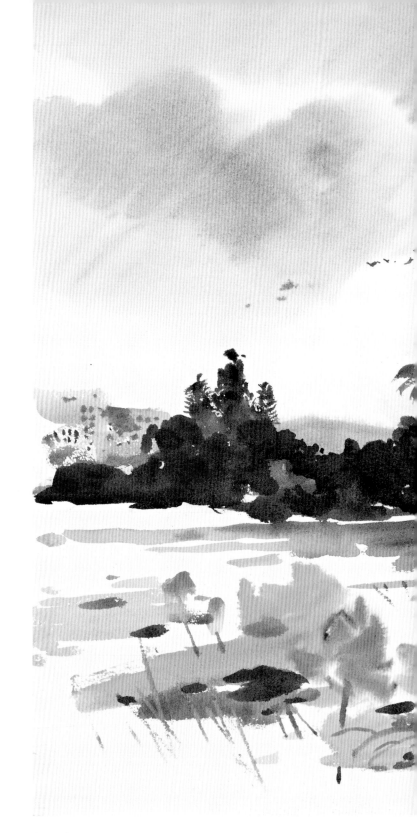

荷花

曲沼芙蓉映竹嘉，
綠江相倚擁雲霞。
生來不得東風力，
終作薰風第一花。

何中

荷塘遠眺101
Across Lotus Pond
57×78cm 2014

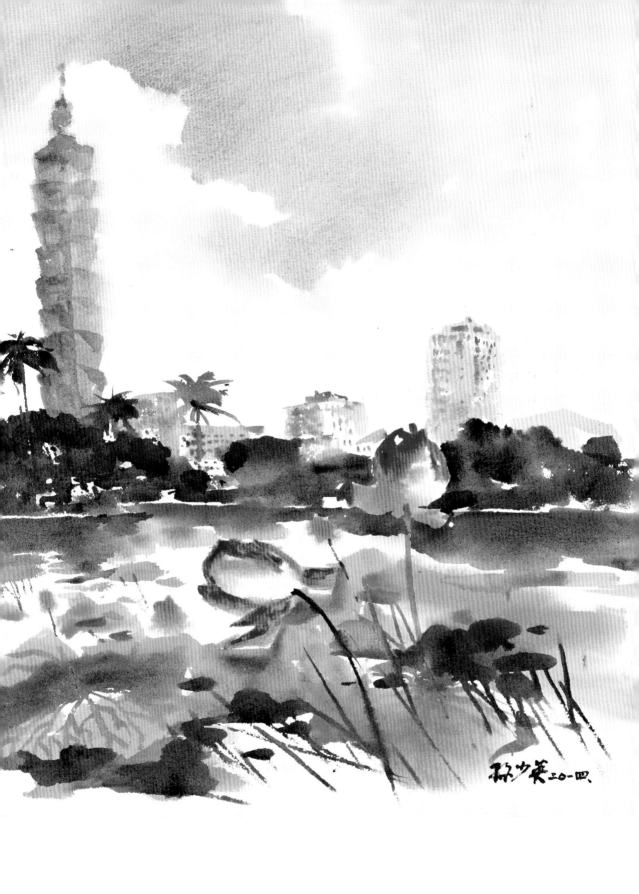

遠眺101
From Afar
29×39cm 2014

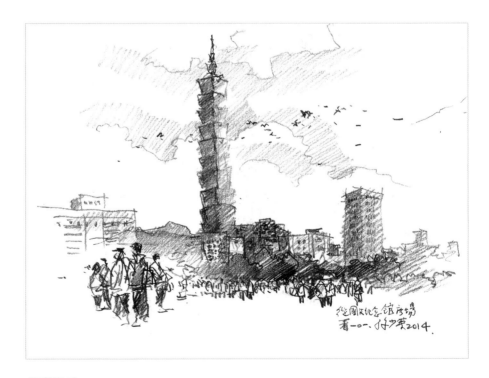

從廣場看101
The 101 Building
29×39cm 2014

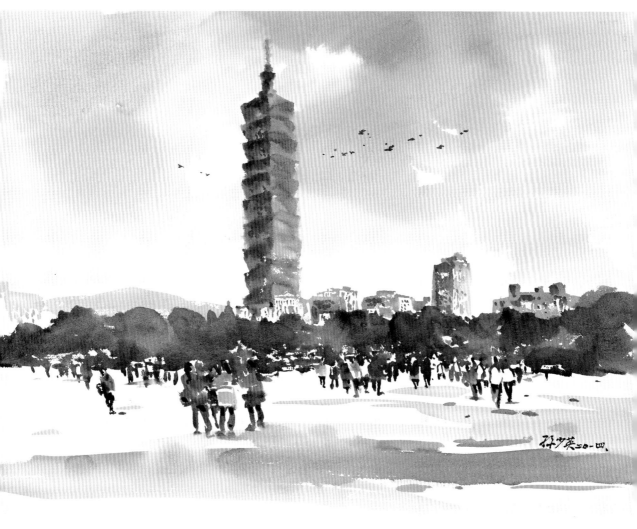

彩霞中的101
Rosy Clouds over 101 Building
57×78cm 2014

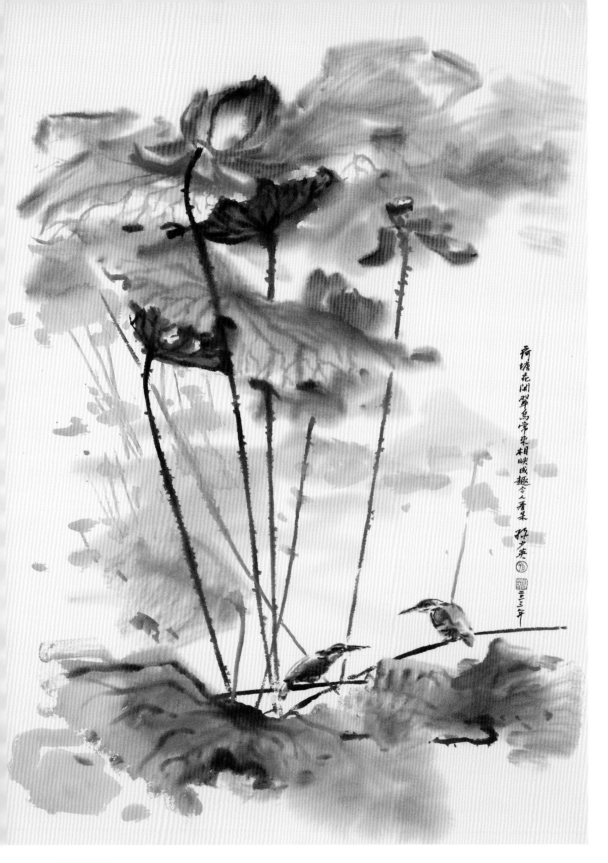

荷塘花開翠鳥常來相映成趣令人看来 孫少英

翠鳥迎春
Kingfisher Greeting Spring
110×79cm　2013

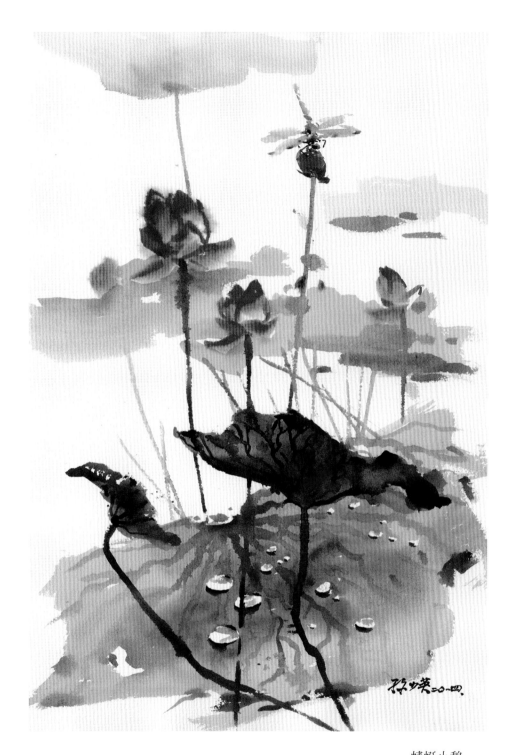

蜻蜓小憩
Stopping by
57×39cm 2014

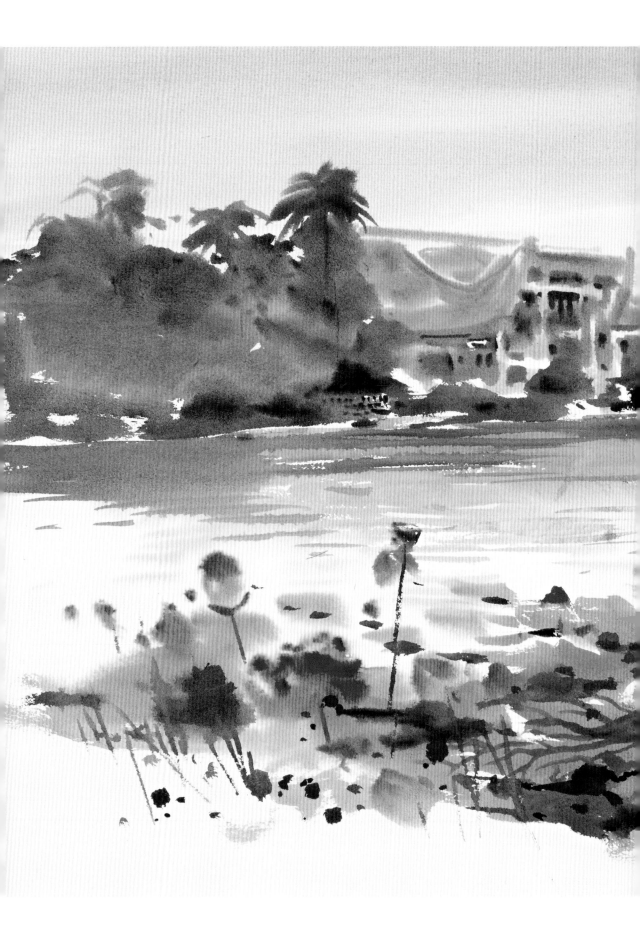

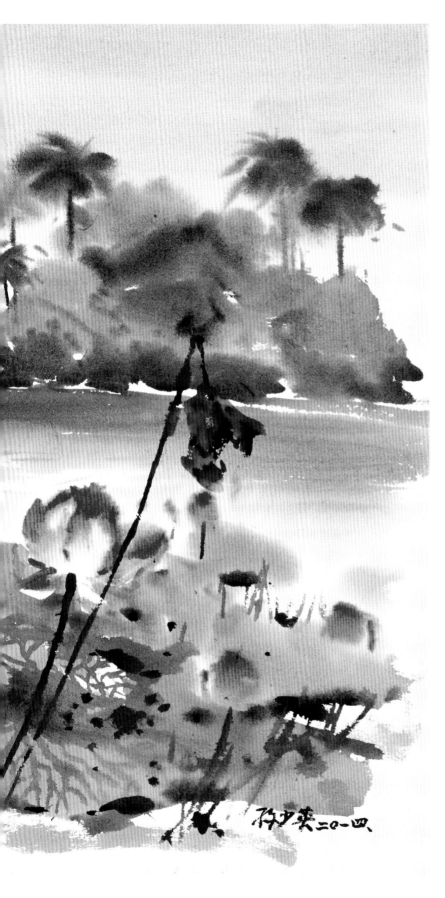

國父紀念館荷花池
Lotus Pond at Dr. Sun Yat-Sen
Memorial Hall
57×78cm 2014

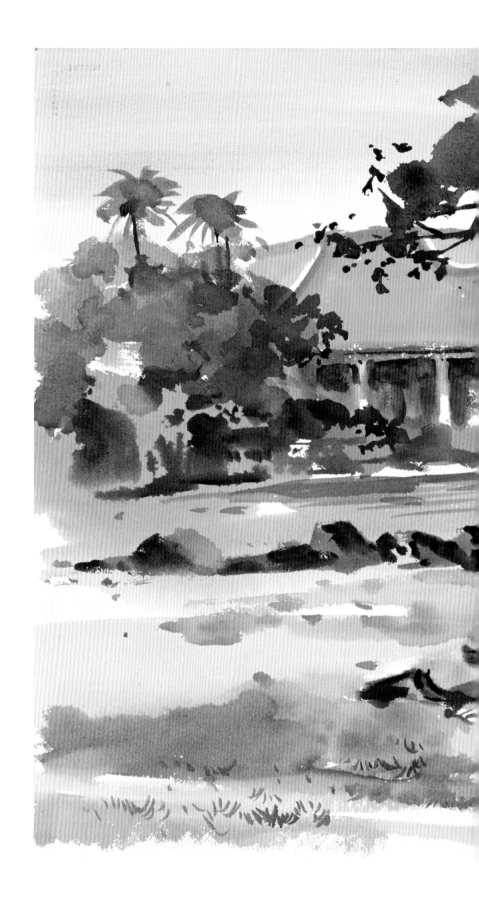

國父紀念館鴿群

Pigeons

57×78cm 2014

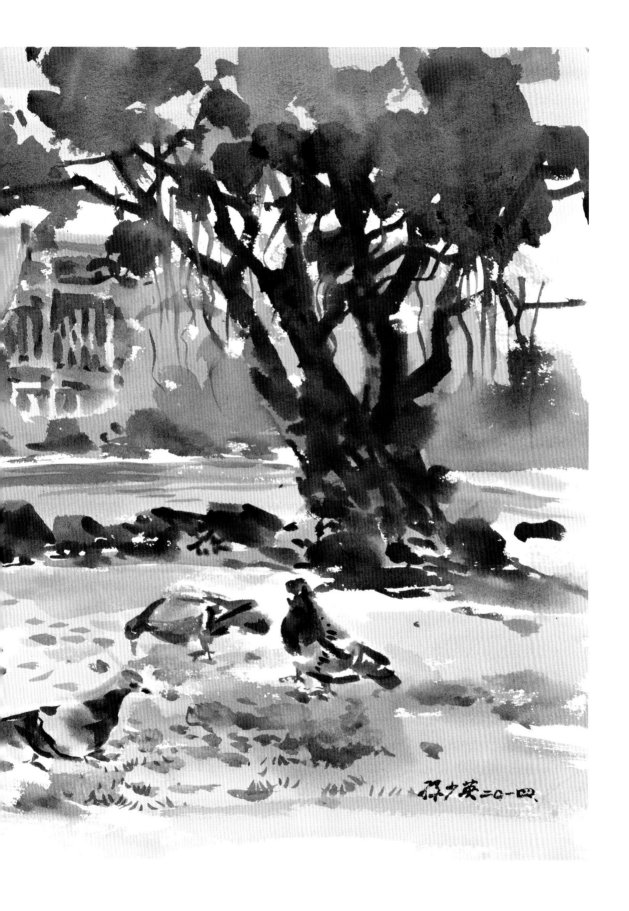
孫少英 二0一四、

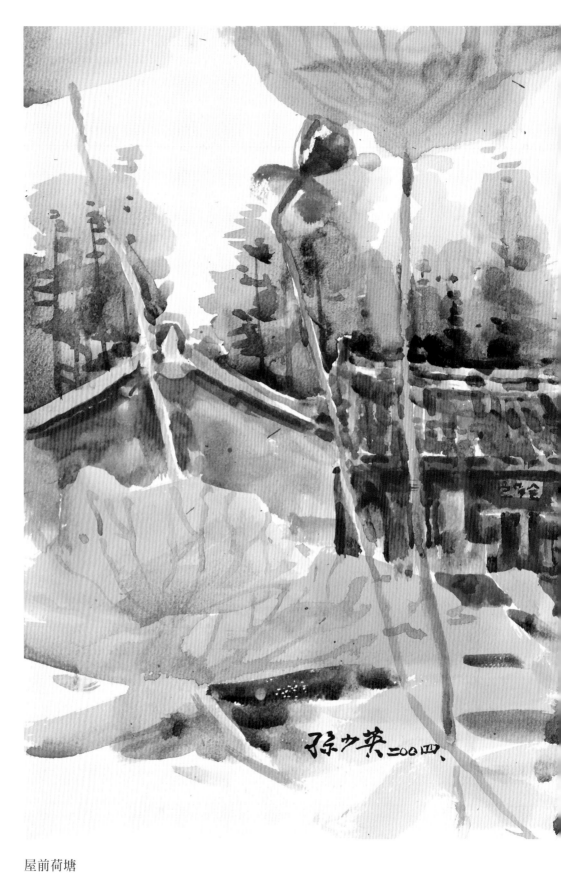

屋前荷塘

Old House by Lotus Pond
39×57cm 2004

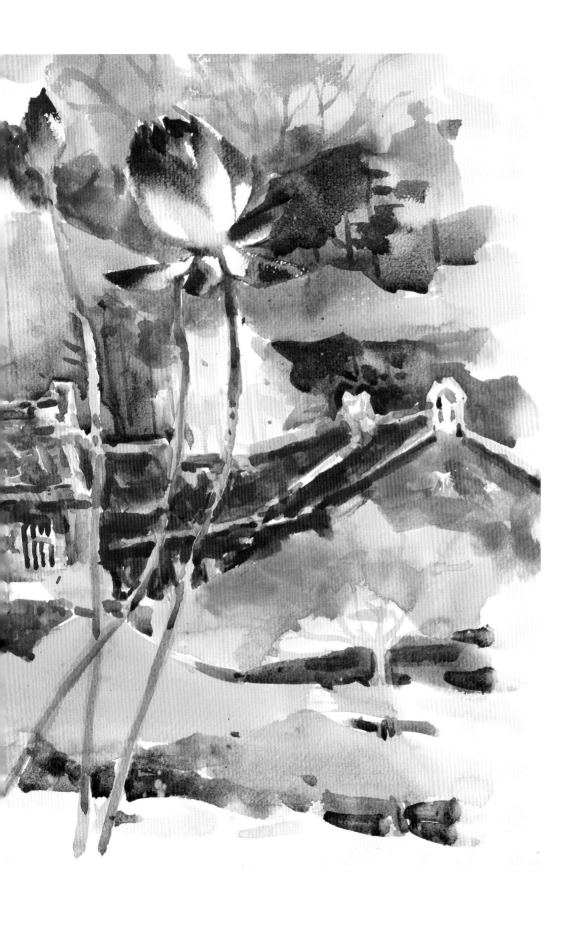

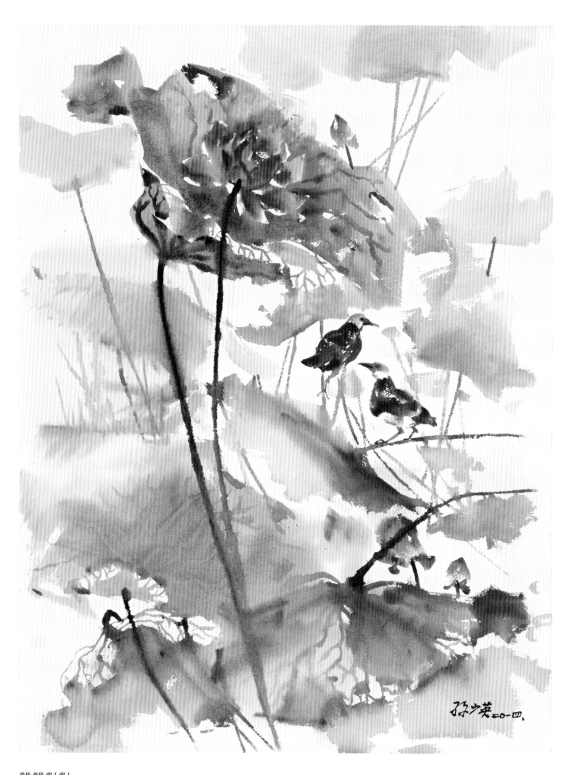

雙雙對對
Love Birds
78×57cm 2014

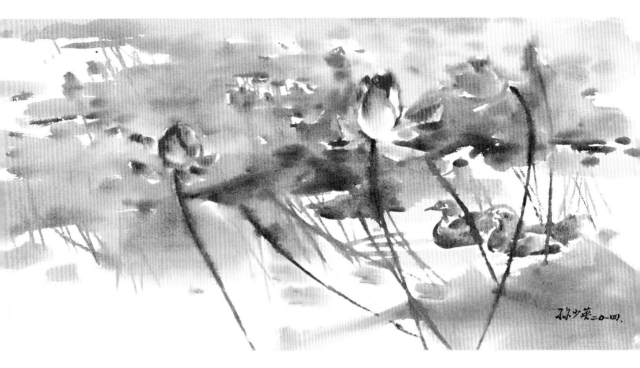

夏日初戀
Summer Love
35.5×72cm 2014

採蓮曲

彩蓮復彩蓮，
盈盈水中路。
鴛鴦觸葉飛，
卸下團團露。

熊卓

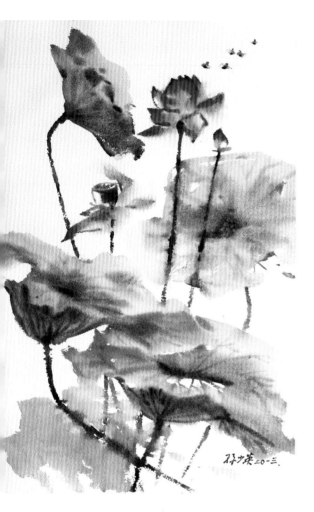

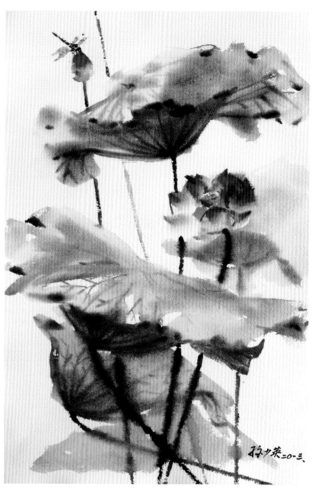

荷花四幅組　荷與蜂
Lotus and Bee
57×39cm　2013

荷與蜓
Lotus and Dragonfly
57×39cm　2013

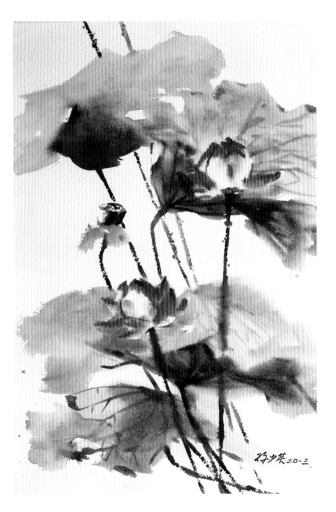

荷與蓬
Lotus and Seedpod
57×39cm 2013

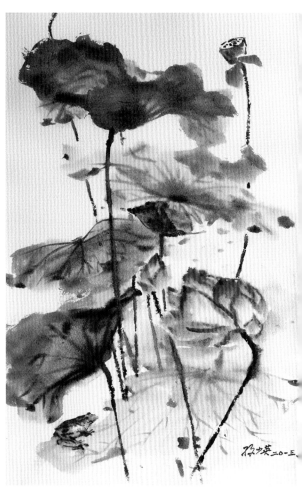

荷與蛙
Lotus and Frog
57×39cm 2013

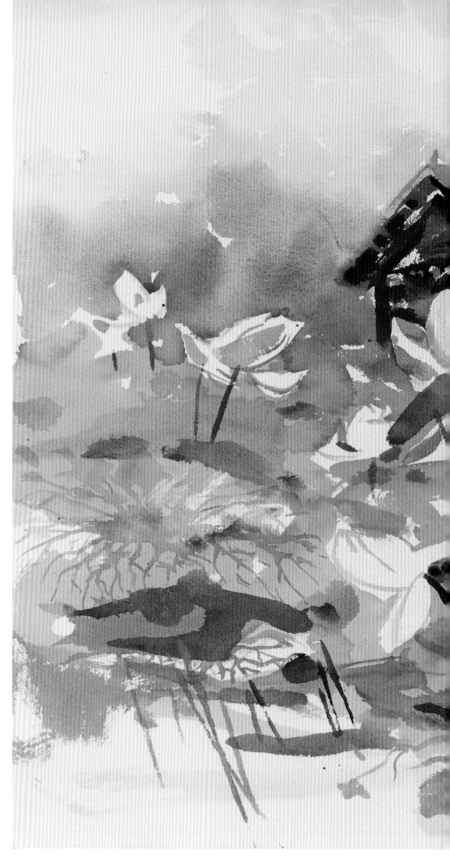

豔冠群芳
Queen of Lotus
57×78cm 2014

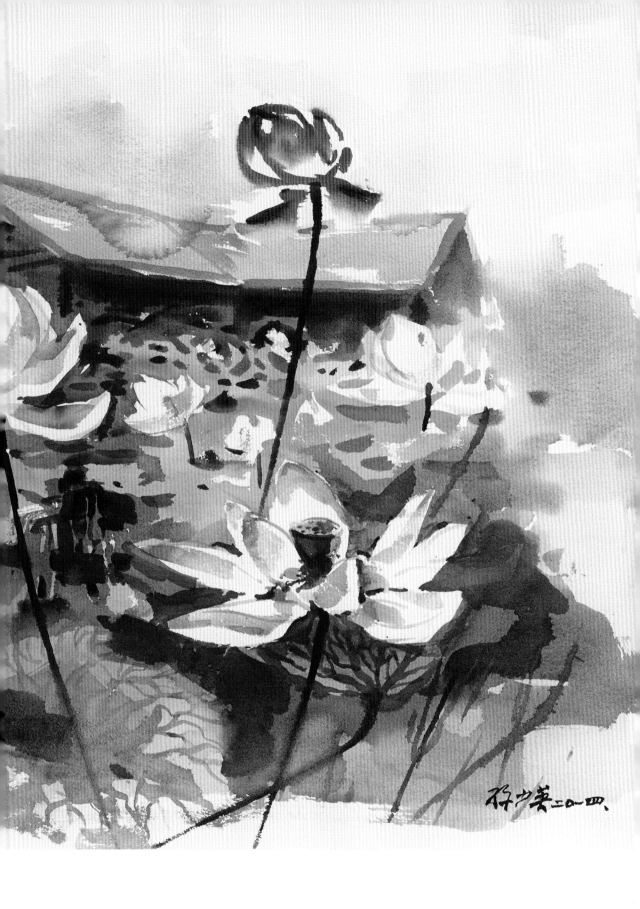

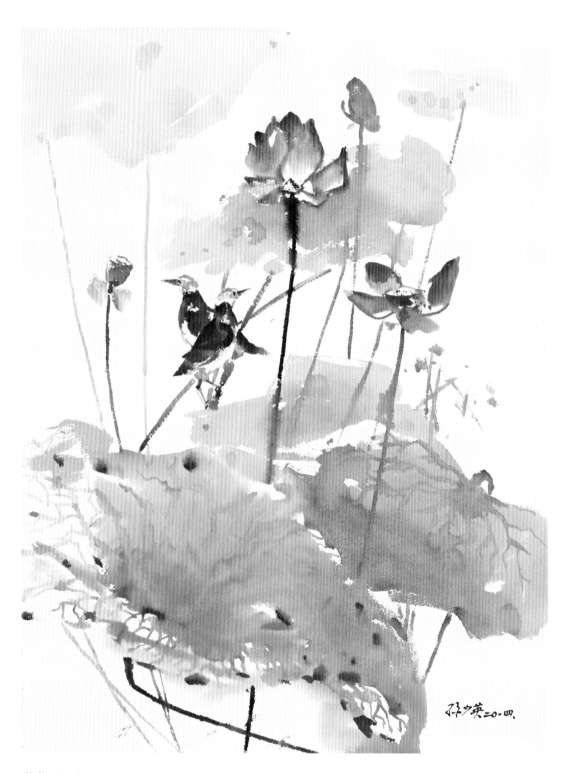

荷花（一）
Lotus (1)
78×57cm 2014

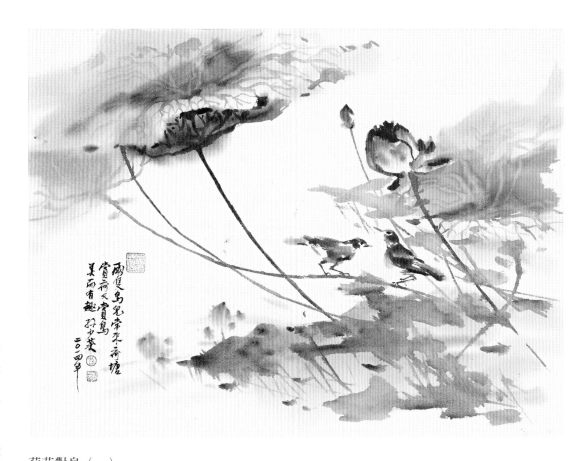

荷花對鳥（一）
Lotus and Bird (1)
57×78cm 2014

詠荷

荷生綠泉中，碧葉齊如規。

迴盪流露珠，映水逐條垂。

照灼此全塘，藻曜君王池。

不愁世嘗絕，但畏盛門移。

張華

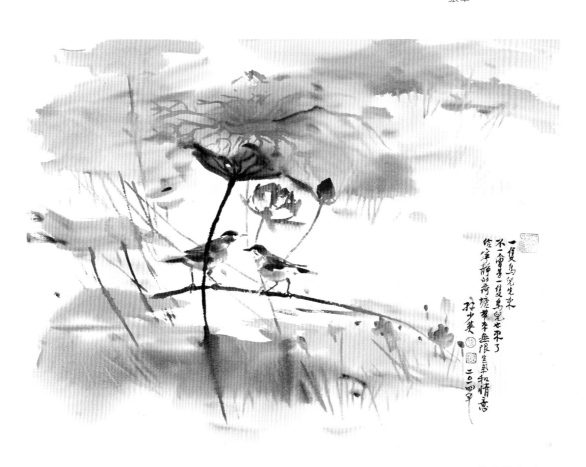

荷花對鳥（二）
Lotus and Bird (2)
57×78cm 2014

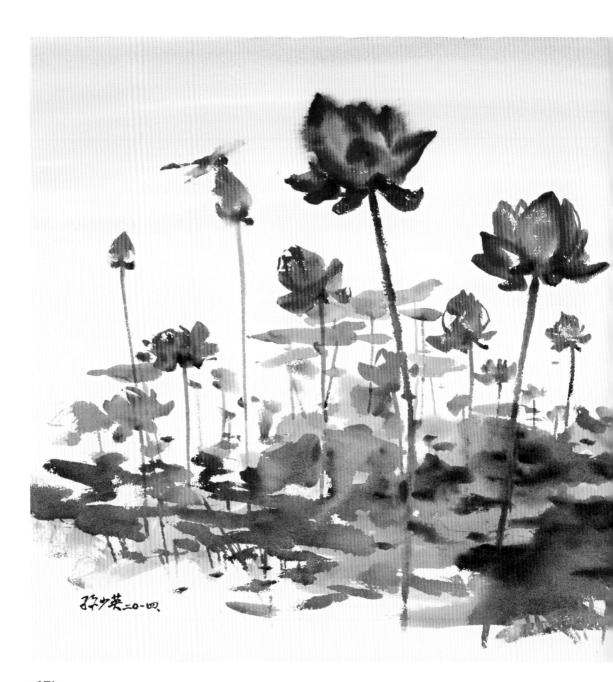

爭豔
Beauty Contest
57×78cm 2014

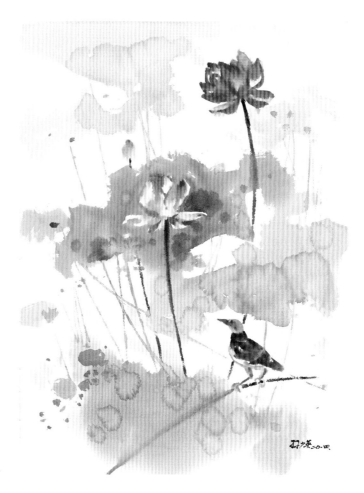

荷池

方池留水勝埋盆，
露入蓮腮沁彩痕。
鈴索無聲人不到，
十禽飛入鬧荷根。

范成大

獨處
Solitary
78×57cm 2014

品令

急雨驚秋曉，今歲秋風早。

一觴一詠，更須莫負，晚風殘照。

可惜蓮花已謝，蓮房尚小。

汀蘋岸草，怎稱得上人情好？

有些言語，也待醉折，荷花向道。

道與荷花，人比去年總老！

<div align="right">李清照</div>

荷塘餐廳
On Lotus Pond
78×57cm 2014

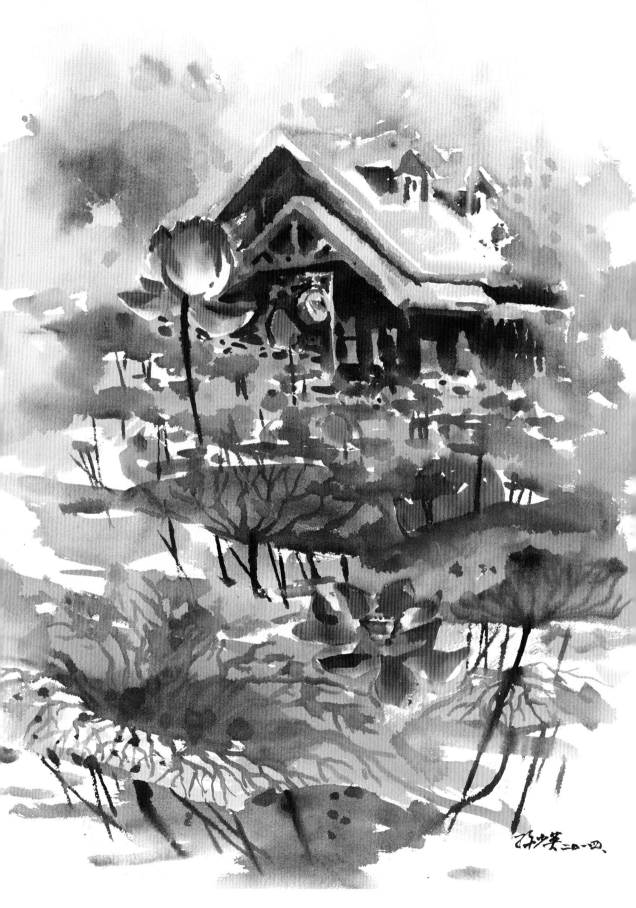

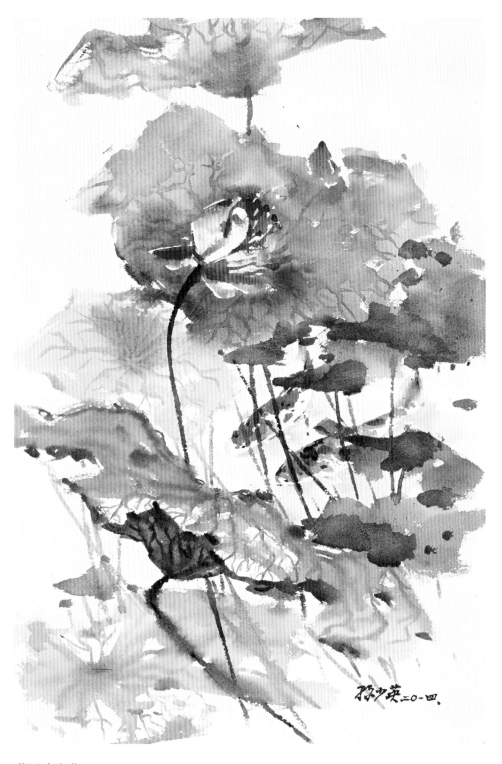

荷風鳴奏曲
Lotus Sonata
57×39cm 2014

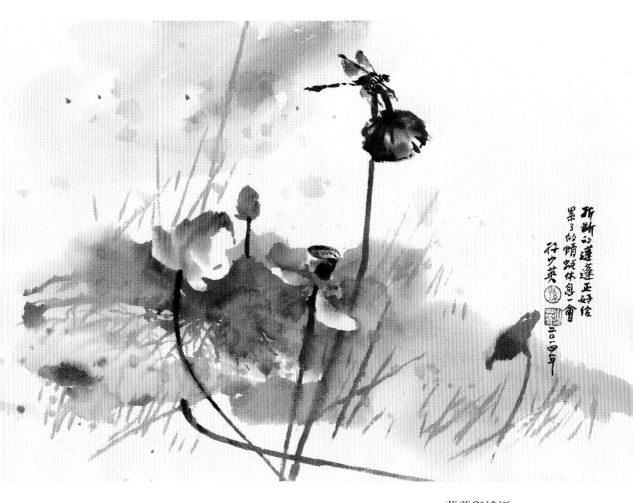

蓮蓬與蜻蜓
Lotus Seedpod and Dragonfly
39×57cm 2014

南歌子

天上星河轉，人間簾幕垂。

涼生枕簟淚痕滋，起觸羅衣，

聊問夜何其？

翠貼蓮蓬山，金銷藕葉稀。

舊時天氣舊時衣，

只有情懷，不似舊家時！

<div align="right">李清照</div>

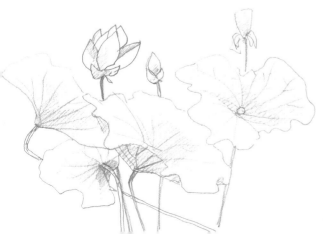

紙教堂夜景
Night View at Paper Dome
29×39cm 2011

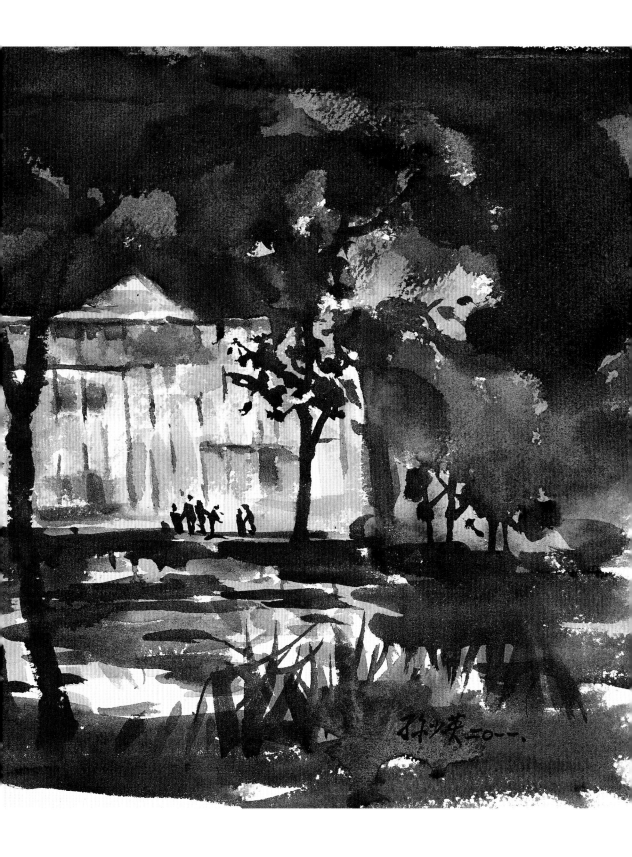

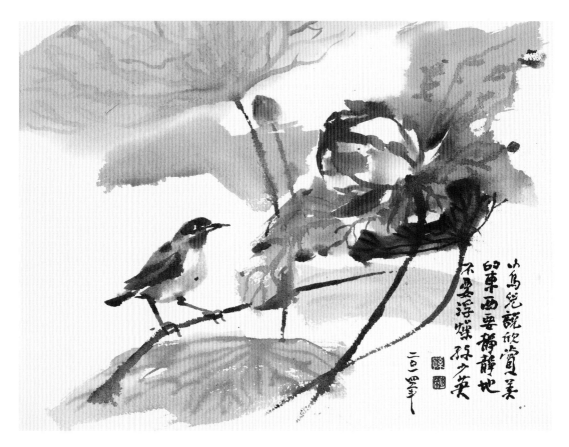

以鳥兒覬覦賞美
臼車西要撐靜地
不要浮躁碌少英

二〇一四筆

對話（一）
Conversation (1)
29×39cm 2014

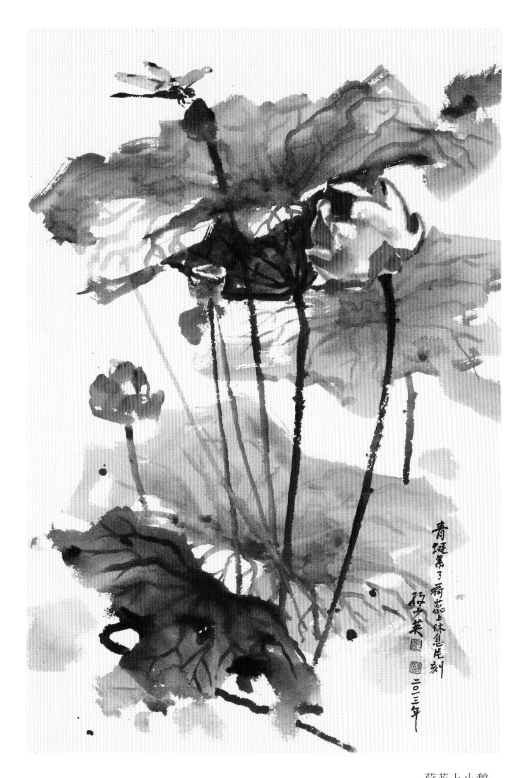

青縫累了荷蕊上休息片刻 孫安葉畫 二〇二三年

荷蕊上小憩
Stopping by
57×39cm 2013

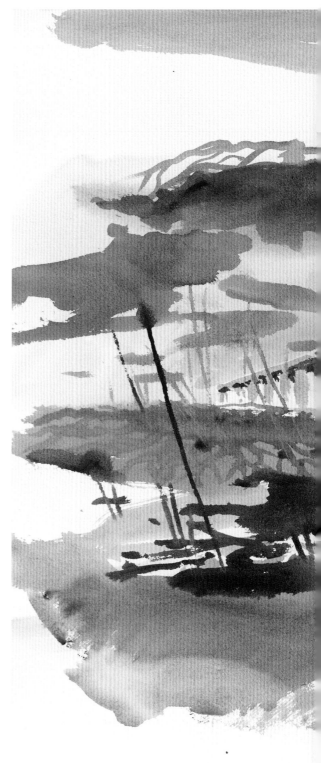

紙教堂荷花季

Lotus Season at Paper Dome
57×78cm 2014

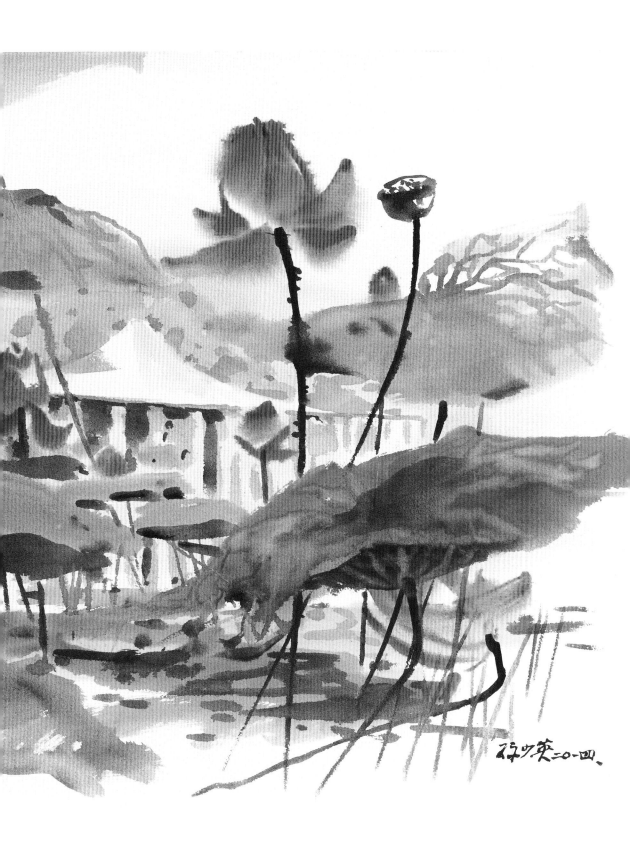

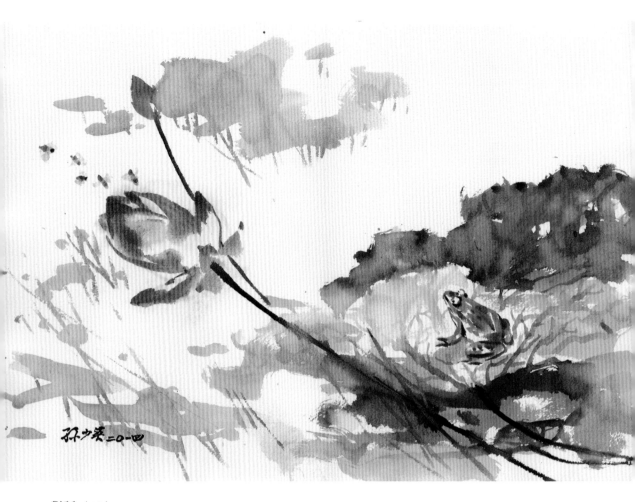

對話（二）
Conversation (2)
39×57cm 2014

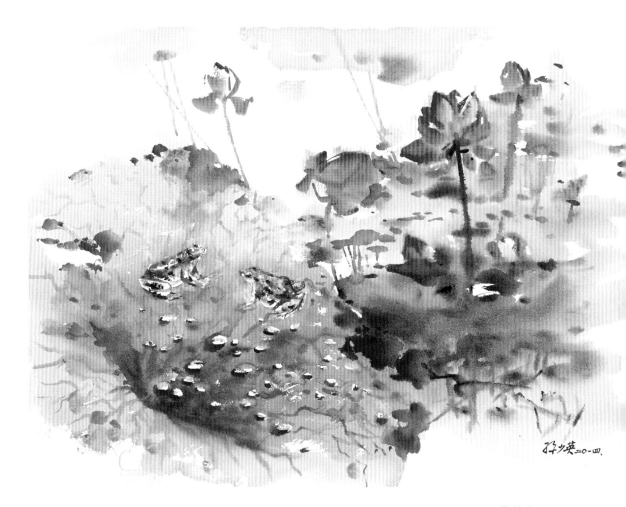

荷葉上
On Lotus Leaf
57×78cm 2014

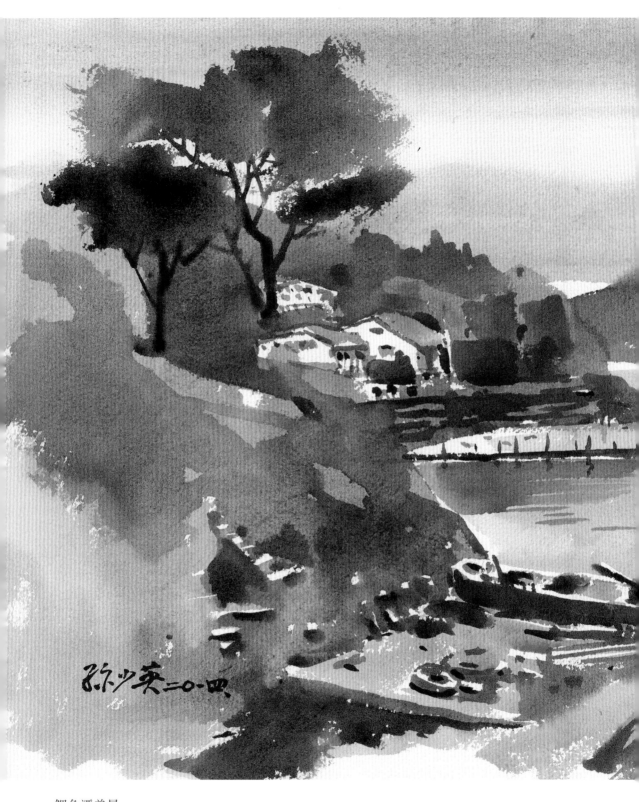

鯉魚潭美景
Liyu Lake
39×57cm 2014

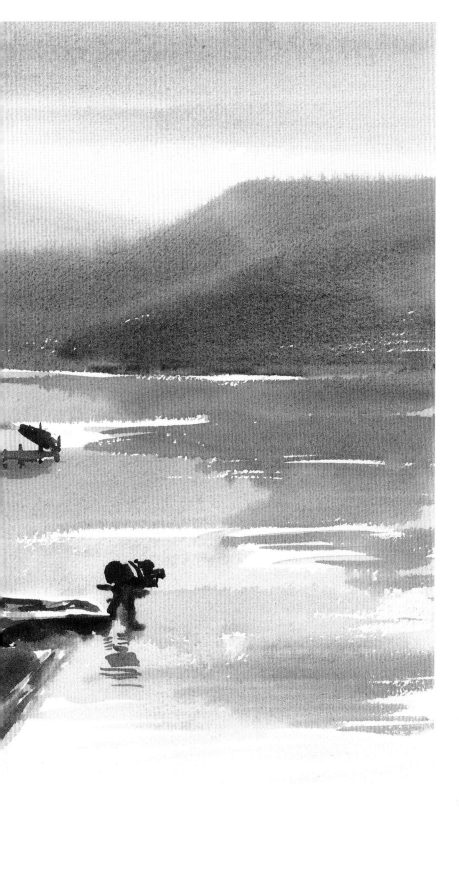

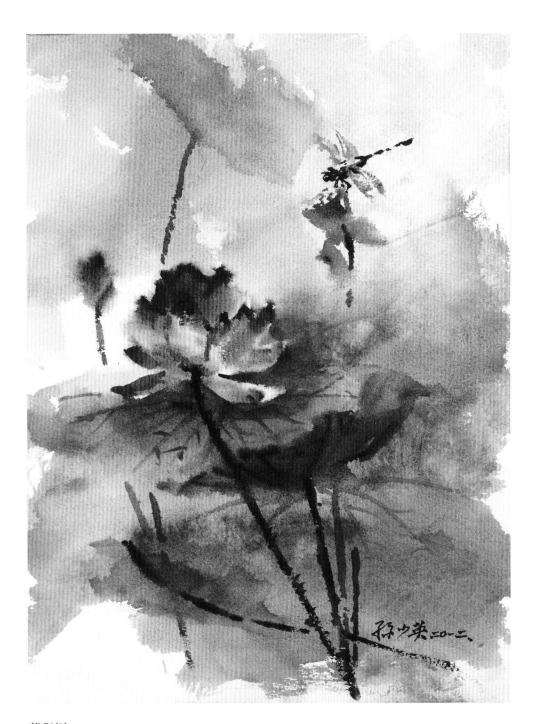

荷與蜓
Lotus and Dragonfly
39×29cm 2012

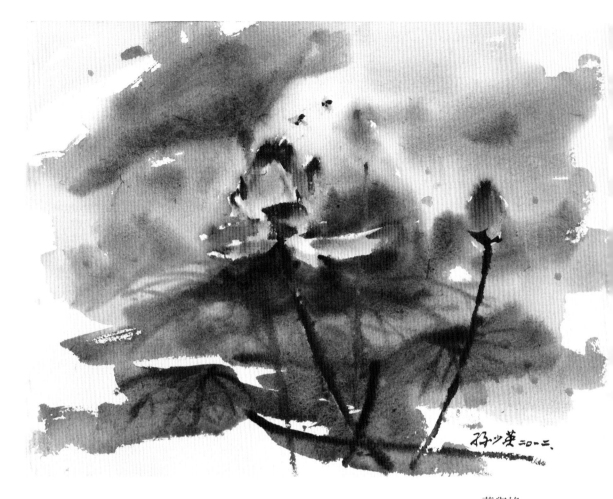

荷與蜂
Lotus and Bee
29×39cm 2012

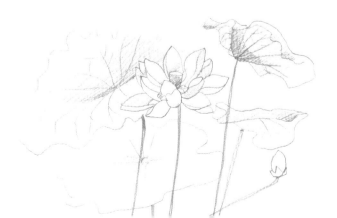

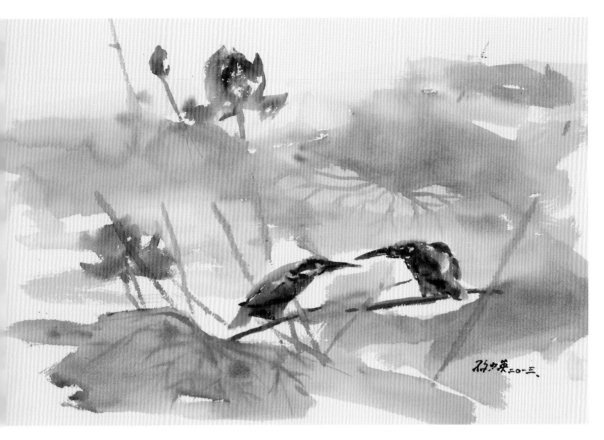

荷花與翠鳥
Lotus and Kingfisher
39×57cm 2013

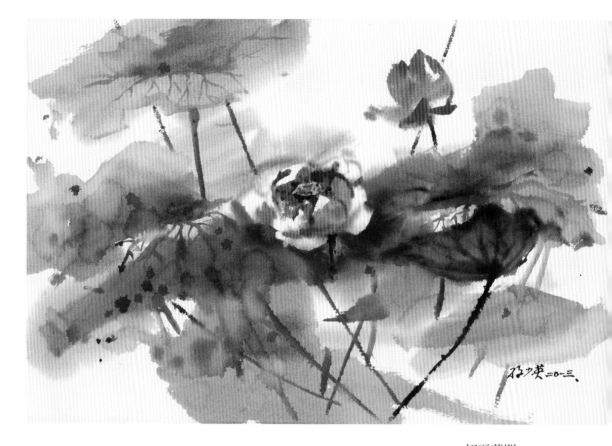

初夏荷開
Early Summer Lotus
39×57cm 2013

看採蓮

小桃閒上採蓮船，
半採紅蓮半白蓮。
不似江南有惡浪，
芙蓉池在臥林前。

白居易

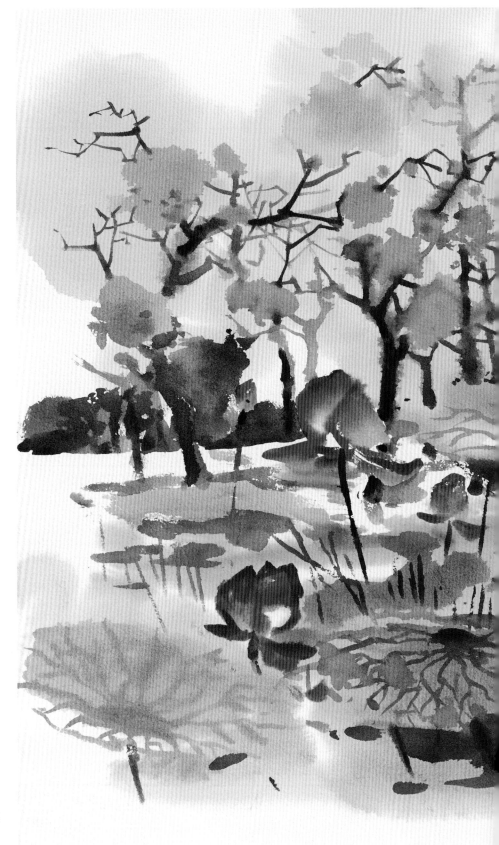

阿勃勒與荷花
Lotus and Abblo
57×78cm 2014

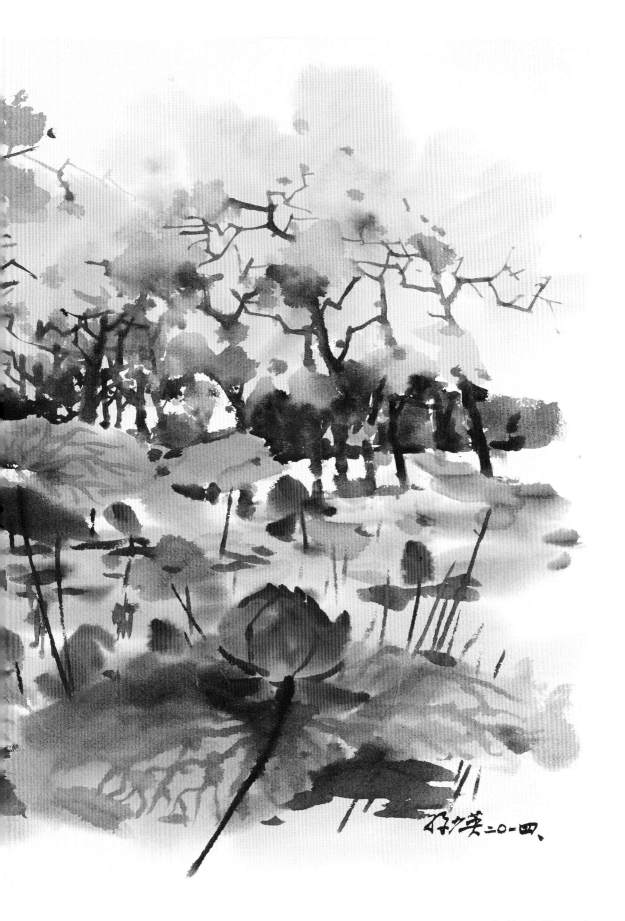

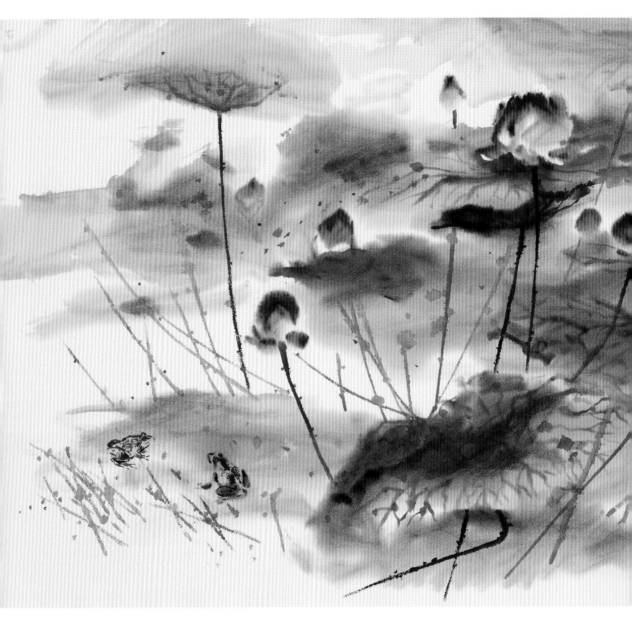

荷塘花開蛙成對
The Frog Couple
79×110cm 2013

荷花

亭亭風露擁川坻，
天放嬌嬈豈自知。
一舸超然他日事，
故應將爾當西施。

王安石

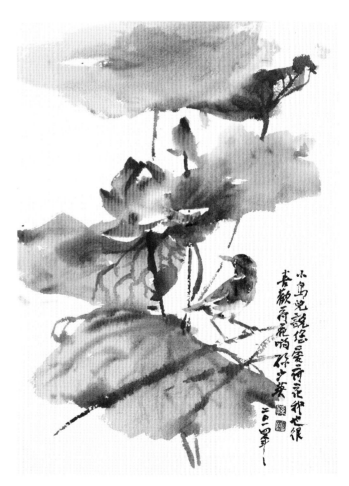

對話（三）
Conversation (3)
39×29cm　2014

贈荷花

世間花葉不相倫，
花入金盆葉作塵。
惟有綠荷紅菡萏，
卷舒開合任天真。
此花此葉長相映，
翠減紅衰愁殺人。

李商隱

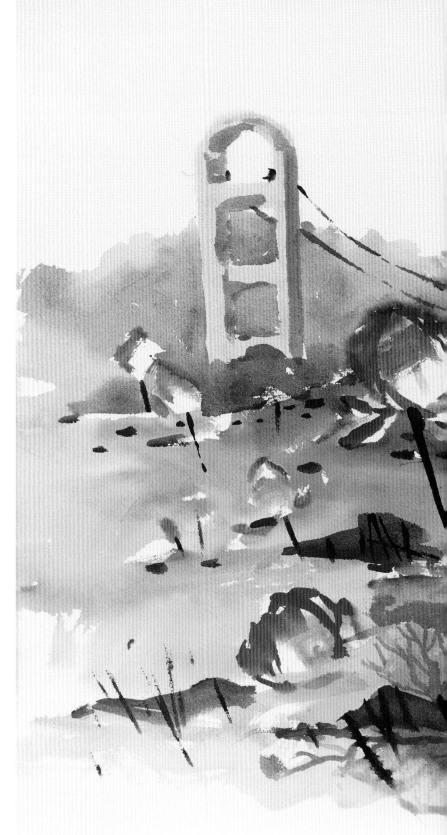

小南海荷塘
Lotus Pond at Xiaonanhai
57×78cm 2014

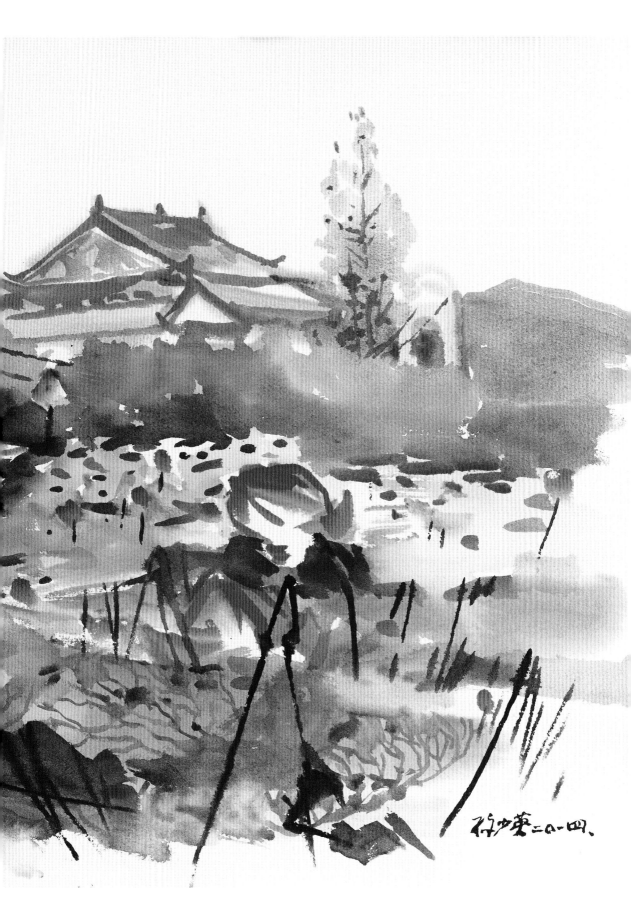

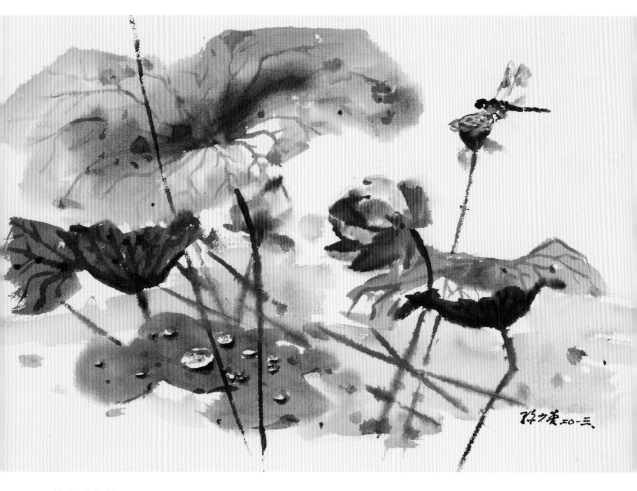

荷花露珠蜓
Dew Drop and Dragonfly
39×57cm 2013

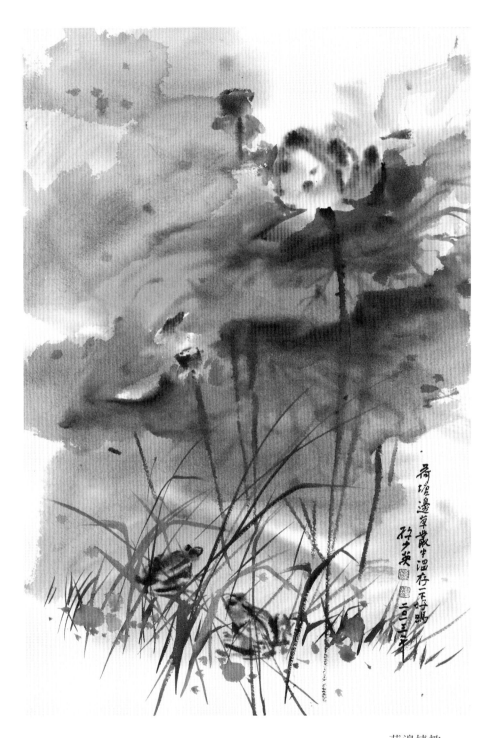

荷邊情趣
Lotus Love Affair
57×39cm 2013

我畫荷花

孫少英

我畫荷花，是從台視退休以後，算起來已有二十四年了。

退休後，住在埔里我岳父翁新宗中醫師的鄉間別墅裡，別墅園區約有二分地，中間是一個大荷塘。岳父年邁，住在埔里市區，別墅完全讓我住。我喜歡寫生，每天騎機車到處寫生，或在荷塘邊畫荷花。有時想想，退休前在台視工作，因工作需要，整天面對電視。退休後，則每天面對畫板，面對原野，面對荷花。所以我的退休生活，實在就是寫生生活，繪畫生活，或是畫荷生活。當然也有看電視，那已是休閒，不是職業了。

有興趣畫荷花，岳父的荷塘對我啟發太大了。開始我先畫鉛筆素描，邊畫邊觀察，荷葉隨風飄動，真是姿態萬種。迎面相對時，荷葉是一個完整的大圓；稍偏時，荷葉的陽面時隱時現，背面時多時少。剎那間的每個樣貌，都是極優美的畫面。平鋪的荷葉上面，會有點點露珠，晶瑩剔透，是荷葉的最佳妝點。

初生的嫩葉，成捲狀，有大有小，有高有低，在高挺的大葉庇蔭下，很像初生的小貓熊。

枯葉，多有捲曲、破損或倒下，色澤黃褐，另有一種美感。紅色蜻蜓最喜歡落在這種枯枝上，十分有趣。

畫荷，花朵當然是重點，從含苞到結子的過程中，我特別喜歡含苞待綻的花朵，很像碩大的水蜜桃，豐滿滋潤。微綻時，多層花瓣重疊有致，像是一個可愛的笑臉。全開時，嫩黃的蓮蓬和蓮絲露出來，會招引成群蜜蜂爬進爬出，忙碌熱鬧如同市集。寫生時，因為專注畫面的營造，欣賞成分大減，為此，我常常寫生完畢之後，呆坐良久，徹底享受純觀賞的樂趣。

寫生畫荷，最好是清晨，有幾個好處：

一、清晨空氣溫潤，色彩和畫紙的融合關係容易掌握。

二、清晨花朵半開或全開形態穩定，晒到太陽後，花瓣變成捲曲，美感大為遜色。

三、清晨花瓣間光影柔和，易於處理。

四、清晨有露珠，是荷葉的最佳點綴，太陽一出來，露珠很快就蒸發了。

五、清晨涼爽舒適，沒有山裡蚊叮咬，塘邊寫生是一種享受。

畫水彩，用具很重要，早期我曾用台灣水彩紙，布紋或博士紙，這種紙吸水性強，有宣紙的性能，畫出來有水墨的韻味。缺點是紙太薄，稍濕後會縐捲、影響運筆。另外是重疊幾次後，會起毛球，畫面不乾淨。最大的問題是時間久了會變黃或褪色，難以保存。

我現在用紙是ARCHES。顏料和筆都是日本製HOLBEIN。

荷花寫生跟風景寫生有些不同，風景的寫實成分比較大，畫荷花擇優重組的成分比較大。

我經常是先以近處的花朵為畫面的基準點，再配以不同形態的葉，這些葉往往不是花的近鄰，而是選自其他各處。有人說，我畫的荷花，像水墨畫，這我承認，我喜歡這種感覺。我想，假若過分寫實，沒有變化，照相就好了，何必寫生、畫畫。

我在畫室裡畫荷花，一定先把紙浸泡三至五分鐘，待紙泡軟了，取出來提看一角，將水滴完，平鋪在畫板上，畫板斜面約二十度，用大刷子把紙壓平，把浮水去掉。面對畫紙，靜下心來，盡快思考構圖，這是一張畫成功與否最重要的時刻。

一般人一定先畫花或是葉，我大半時間則是先畫小動物，譬如畫兩隻多情的鳥，牠雖不是主角，但絕對是極重要的配角，如果是畫完了花和葉以後，再找空間補兩隻鳥，補不好，很像違章建築，或是畫蛇添足，影響大局。所以我會很有計劃的先畫兩隻鳥，然後花、葉、蓬、莖順勢一氣呵成。如果是畫蜜蜂、蜻蜓或是青蛙，因是附著在花、葉或莖上，後畫較宜。

畫花，我習慣三層著色，第一層淺色渲染，第二層在花的尖端及花瓣接合處加深，最後在尖端再加深，以表現花瓣層次及立體感。畫花的顏料，主要的有兩種：

ROSE MADDER 和 OPERA（玫瑰紅和洋紅）

畫荷葉，我覺得比畫花變化多，難度也似乎較高。最初我都是參考素描稿，有計畫的勾出形狀，再按翻轉的形態重點加深。看起來很單純的一片葉子，由於它翻轉形式、光影濃淡、色塊大小以及方向角度的不同，畫起來變化極多，也極有趣味，這要靠細心觀察和常常練習。最後勾葉脈很重要，要根據葉子翻轉的相貌，或直或彎，或長或短，勾的恰到好處，葉子翻動的神態才會出現。我畫荷這些年，一直很重視葉子的畫法，畫得好，不僅僅是配襯，反而是精華所在。

花梗或是葉梗都是線條，比起花與葉的畫法簡單多了，重要的是要挺硬，切忌軟弱，注意斜度變化，避免平行呆板。

前面說過，我初畫時，都是參考素描稿，畫多了，會不願受畫稿的拘束，我改用大筆蘸色，隨興大塊塗抹，稍乾後，依色面形狀，細心分出濃淡，耐心勾勒細部，我想這可能類似張大千的潑墨，比全部計劃性的畫法生動活潑。

畫西畫都是簽名，沒有落款。好友楊本湛先生看我畫荷花，幫我刻了幾方印章，我試著落款，初次嘗試，覺得效果不錯，就漸漸習以為常了。

說起落款，要書法不錯，好在我幼年時，被父親逼著練字，歐柳顏趙都臨摹過，蘇黃米蔡也探討過。現在老了，每一寫字，都會感念父親當年教導的恩澤。

台灣的荷塘、荷田很多，我自從有興趣畫荷以後，從北到南著名的荷園我都去看過畫過，台北歷史博物館的荷園最為有名，面積大，環境好，經常吸引大批攝影者、寫生者和單純愛荷者在周邊活動。園中鳥類很多，我最喜歡一種紅冠水雞，浮在水面很像小鴨，飛出水面又是大鳥，不時發

出唧唧叫聲，十分可愛。

國父紀念館中山公園內翠亨湖中有圈起來的荷叢，六七月間荷花盛開時，網籬內爭奇鬥艷，很像舞台上選美的佳麗。

桃園縣觀音鄉的荷田，具有農業和觀光雙重價值，由農會輔導。我發現這裡品種最多，單瓣複瓣、黃色紫色、大花小花，十分可觀。但是看來看去，我還是覺得常見的高挺大葉、紅花白花的一般品種最好也最多，同時也是荷農最樂於栽培的生產主力。

中興新村省府大道兩側的荷池，是中興新村的美麗地標，也是附近許多觀光店家生意依存的景觀和賣點。

埔里鎮紙教堂見學園區利用周邊的農田種植了大片荷花，每年都請白河的種荷師父來清疏、施肥、整理，故生長極為茂盛，開花也多，我每年都約許多畫友到這裡寫生。

台南市白河的荷花應是台灣最有名了，荷田多，面積大，最有看頭的是他們極力標榜的賞荷大道，數百公尺筆直大道兩側清一色的荷田，沒有其他農作物交雜其中。這一帶都是平原，幾乎看不到山，一望無際的荷田，如同荷海。荷田的水源來自小南海，小南海原名永安湖，屬雲嘉水利灌溉系統，提起這個水利系統，自然會想到日本時代的水利專家八田與一先生，他是雲嘉水利系統的設計、開發、創始者。飲水思源，八田與一先生對台灣農業貢獻實在太大了。

畫荷花的媒材很多，主要的有水墨、油彩和水彩，水墨畫重墨韻和線條，多以單株表達，以意境見長，色彩較弱。油畫多以寫實或意象為重，以荷花為題材的油畫家不多。水彩則以色彩和水分見長，單株或是全面，寫實或是意象，均有全能表達之特性，多年來的經驗，我覺得要切實掌握荷花多變的姿態，風吹的動感及其特有的神韻，水彩是最適當的，也可能是最優越的。

My Lotus Paintings ⟋⟍⟍⟍⟍⟍⟍⟍ Sun Shao-Ying

I have painted lotus flowers for already 24 years since my retirement from Taiwan Television.

After I had retired, I have lived in the country villa of my father-in-law, the Traditional-Chinese-Medicine doctor Weng Xin-zong, in Puli. The entire villa area is around 2000 square meters, including a big lotus pond in the center of the garden. My father-in-law is old and lives in the urban area of Puli, allowing me to take full occupancy of the villa. I like to draw from life, so I ride my motorbike everywhere each day for nature painting or just paint the lotus flowers by the pond. I cannot help thinking that before retirement my job at Taiwan Television was to face TV all day long, yet after retirement I am facing the painting board, nature and lotus flowers every day. Therefore, my retirement life is indeed a life of nature drawing, painting or lotus painting. Or course I also watch television sometimes, but it has become a leisure activity rather than a profession.

I have developed an interest in painting lotus, because the lotus pond of my father-in-law has enormously inspired me. At the beginning, I would do a pencil sketch and then I continue to draw as I observe the various forms of lotus leaves swinging in the wind. When I come face to face with them, the lotus leaf features a complete big circle; and if I shift to a tilted view, their sunny sides appear to be hidden or visible at intervals. Every appearance of them at each moment is an extremely beautiful picture. On the flat surface of the lotus leaf are lying beads of dew, transparently glowing, as the perfect garnishment.

The sprouting tender leaves are curly, big or small, high or low, which very much look like newly born baby pandas, under the shade of large outstanding leaves.

Dried leaves are mostly curly, broken or fallen, with a yellowish-brown coloring, showing a different sense of beauty. Red dragonflies like it best to stand on this kind of dried twigs, which is a very amusing scene.

To paint the lotus, the essential object is certainly the flower. During its process from budding to bearing fruits, I particularly like the flower in bud, which looks like a giant peach, plump and moist. When its petals are slightly opened in multiple layers, it looks like a lovely smiling face. When it is completely blossoming, its tender yellowish lotus seed head and threads are exposed, attracting swarms of bees bustling in and out like a market place. During my nature drawing, I am fully engaged in constructing my picture, giving up the chance of appreciation. Therefore, I often take time to sit in stillness after I have finished painting, and completely bath myself in the pleasure of observation.

It is best to paint the lotus in nature during the early morning, which offers several advantages.

1. The air in early morning is moist, facilitating the integration between coloring and drawing paper.
2. Flowers in early morning are either half or complete opened in a stable form. Yet when touched by the sun light, petals become curly and their splendid beauty dwindles away.

3. The light and shadow amid petals in early morning is soft, which can be easily handled.

4. In early morning, there are drops of dew as the best garnishment for lotus leaves, which will soon be evaporated after the sun comes out.

5. It is cool and cozy in early morning without the mountain mosquitoes threatening to bite. To sketch by the pond is sheer enjoyment.

Art supplies are very important for watercolors. In early time, I had used Taiwan watercolor paper, either wove paper or boshi paper, which is highly absorbent like rice paper, capable of creating the poetic effect of ink painting. One of the shortcomings is its extreme thinness that would make the paper curly when slightly moistened, which affects the brushwork. Another is that the picture plane looks unclean with fuzz balls after repeated overlapping. Yet the biggest problem is that it would turn yellowish or fade over time, making it hard to preserve.

Now I simply use Arches paper and Japanese-made Holbein pigment and brushes.

It is somewhat different between sketching lotus and landscape. A landscape work is more realistic, while painting lotus is rather like recomposing the better choices.

I often take the nearby flowers as the starting point and then match them with different types of leaves. These leaves are usually not neighbors of those flowers but chosen from other various locations. Some people say that my lotus paintings are like ink paintings, which I do agree. I like this kind of feeling. In my opinion, extreme realism without variation can be simply achieved by photography, needless to sketch or paint.

When I paint lotus flowers in the studio, I always soak the paper beforehand for 3-5 minutes. When the paper is softened, I hold it at one corner to let water drip down and then spread it on the board which is tilted at around 20 degrees. And I use a big brush to flatten the paper and get rid of the surface water. I face the paper and calm down to quickly think up the composition. This is the most important moment for determining the achievement of a painting.

Ordinary people would certainly paint flowers or leaves first. But most of the time, I begin with painting little animals, such as two passionate birds. They may not be the leading figures, but, undoubtedly, extremely important supporting roles. It would be redundant or look like illegal construction to have failed in finding the space to supplement with two birds if we finish painting flowers and leaves first. Then the whole composition would be ruined. Therefore, I would plan the composition in advance to paint two birds first and then finish painting flowers, leaves, seed heads and stems coordinately at one go. Yet, for painting bees, dragonflies or frogs, because they are attached to flowers, leaves or stems, it is better to be done afterwards.

For painting flowers, I am used to do three-layer coloring. The first layer is undertone rendering. The second layer is to deepen the color on the joint of flower tips and petals. And the last layer is to deepen more on the tips in order to demonstrate the layering petals

and three-dimensionality. My choice of pigments for painting flowers are mainly two kinds: rose madder and opera.

For me, painting lotus leaves is more variable and somehow harder than flowers. At first, I always refer to sketches, thoughtfully profiling them and highlighting the overturning forms. A single leaf may look simple, but can be very interesting in many drawn variations created by its overturning styles, light and shade, color areas and different angles. It requires careful observation and frequent practice. Finally, it is very important to delineate leaf veins, according to the overturning form, straight or curvy, long or short. Only proper delineation will demonstrate the overturning manner of a leaf. Over the years of painting lotus, I have always paid attention to the drawing of leaves, which could be the essence of a work rather than a merely contrast if done well.

Flower stems or leaf stems are both lines, which are easier to paint than flowers and leaves. The key point is to make them look straight and firm, avoiding weakness, and emphasize the tilted variation, avoiding parallel and dullness.

I have already mentioned that in early time, I had always referred to sketches, but after I had accumulated more experiences, I became reluctant to be limited by sketches. I have changed to use large brushes for coloring and spontaneously daubing masses. After the paper is slightly dried, I would carefully divide the shades of color according to color fields and shapes, and patiently delineate the details. I think it is more like Zhang Daqian's splash-ink painting, which is more lively and dynamic than a well-planned drawing.

I always sign on my western-style paintings without inscription. Mr. Yang Ben-zhan, a good friend of mine, learned about my lotus paintings and sent me several seals. So I tried to inscribe with seals. The first trial was pretty effective. Therefore, I have gradually developed this habit.

Speaking of inscription, it requires good calligraphy. Thanks to my father who had forced me to practice since my childhood, I had imitated and studied the styles of most old masters. Now I am old, and when I write calligraphy each time, I would remember my father's kind teaching with gratitude.

There are many lotus ponds and fields in Taiwan. Ever since I had developed an interest in painting lotus, I have visited and painted all famous lotus gardens across Taiwan. The most famous one is the lotus garden at the National Museum of History in Taipei, which has a big area and good environment, usually attracting a large number of photographers, nature painters and pure lotus admirers hanging around. There are a lot of bird species in the garden. My favorite bird is Eurasian Moorhen, which looks like a duckling when floating on water surface but becomes a big bird when flying out of water. It is very adorable, giving cheeping sound on and off.

There are circled lotus clumps inside the Cuiheng Lake of Zhongshan Park at Sun Yat-sen Memorial Hall. Between June and July when lotus flowers are in bloom, it is like

a beauty pageant inside the net fence, joined by beautiful flowers competing with one another.

The lotus fields of Guanyin Township in Taoyuan County are instructed by Farmers' Association, valuable in both agriculture and tourism. I find that here they have remarkably the largest variety of lotus flowers, including single or multiple petals, yellow or purple colors, large or small flowers, etc. But after all, I feel the general type is the best and the largest group, commonly seen as highly standing large leaves with red or white flowers, which is also lotus farmers' favorite breed for major production.

The lotus ponds along both sides of Shengfu Boulevard at Zhongxing New Village are a beautiful landmark here, also a scenic spot and tourist attraction for many nearby stores relying on tourist business.

The Newland Community Education Center of Paper Dome at Puli Township has used the surrounding fields to grow seas of lotus flowers. Every year, lotus masters from Baihe are invited to dredge, fertilize and sort out the fields, so they are extremely flourishing with abundant blossoms. I invite many painter friends to come here each year for nature painting.

The most famous lotus flowers in Taiwan should be those at Baihe, Tainan City. There are many lotus fields in large areas. The most notable spot is their greatly self-praised Lotus Boulevard, a straight route as long as hundreds of meters bordered with pure lotus fields without any other crop. This is a plains region, almost without any mountains in view. The extensive lotus fields stretching to the horizon are like lotus seas. The water source of lotus fields comes from Xiaonanhai, originally named Yongan Lake, belonging to the irrigation system of Yunlin and Jiayi. At the mention of this irrigation work, we would naturally think of Mr. Yoichi Hatta, a hydraulic engineer of the Japanese Period, who was the designer, developer and creator of Yunlin-Jiayi Irrigation System. We should be grateful for Mr. Yoichi Hatta's enormous contribution to Taiwan's agriculture.

There are a lot of media that can be adopted to paint lotus, including ink, oil and watercolor. The ink painting emphasizes ink effects and lines, mostly featuring a single plant, good at temperament but poor at coloring. The oil painting mainly values realism or imagery, so there are few oil artists choosing the subject of lotus. The watercolor painting specializes in coloring and moisture, capable of representing the complete characteristics of lotus, whether a single plant or overall view, in realistic or imagery style. According to my years of experiences, I consider watercolor to be the most suitable and perhaps the most excellent way to grasp the various forms, motion in breeze and special manners of lotus flowers.

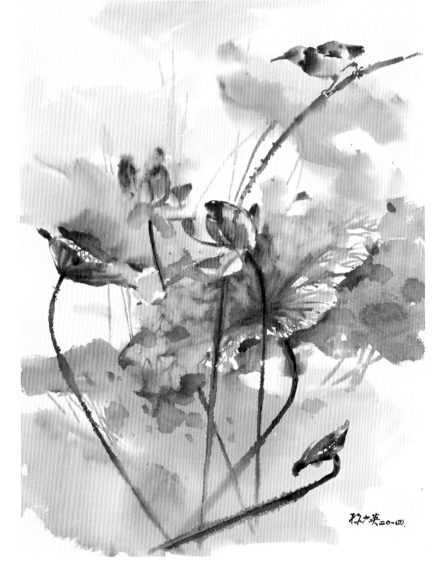

常記溪亭
日暮沈醉不知
歸路興盡晚
回舟誤入藕花
深處爭渡爭渡
驚起一灘鷗鷺

李清照如夢令
酒興

孔少英書
二0二四年

荷聯（一）
Lotus Poetry (1)
78×57cm 2014

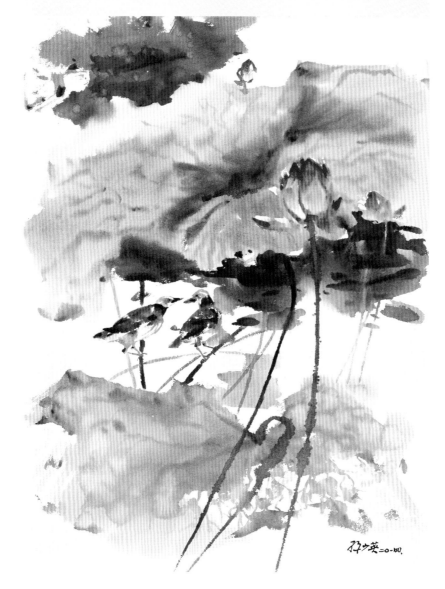

芰荷彩花
曉艷開濃妝
美笑面相偎
西方采畫嘉
陵鳥早晚雙
飛池上來

劉商詠懷用蓮花
孫少英書
二0一四年

荷聯（二）
Lotus Poetry (2)
78×57cm　2014

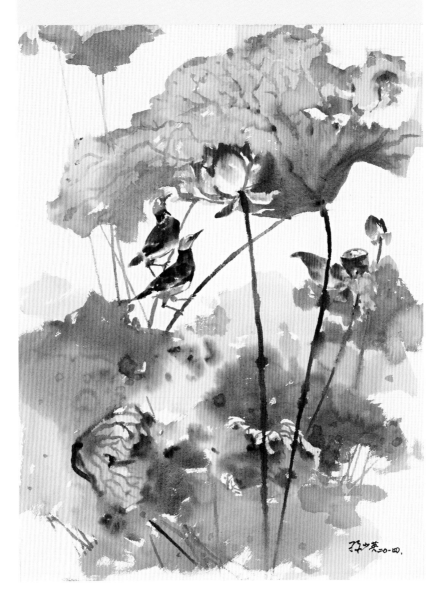

畢竟西湖
六月中風光不
與四時同接天
蓮葉無窮
碧映日荷花
別樣紅

蘇軾西湖
孫少英書
二〇一四年

荷聯（三）
Lotus Poetry (3)
78×57cm 2014

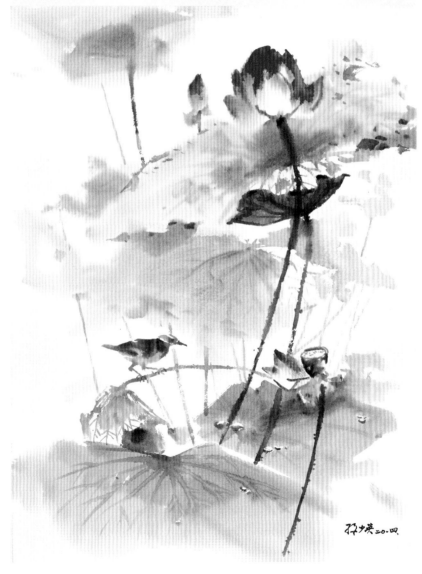

方池留水
勝埋盆甕入
蓮腮沁粉
痕鈴索魚無聲
人不到小禽飛
入閒荷根

元范成大荷池
孫英書
二〇一四年

荷聯（四）
Lotus Poetry (4)
78×57cm 2014

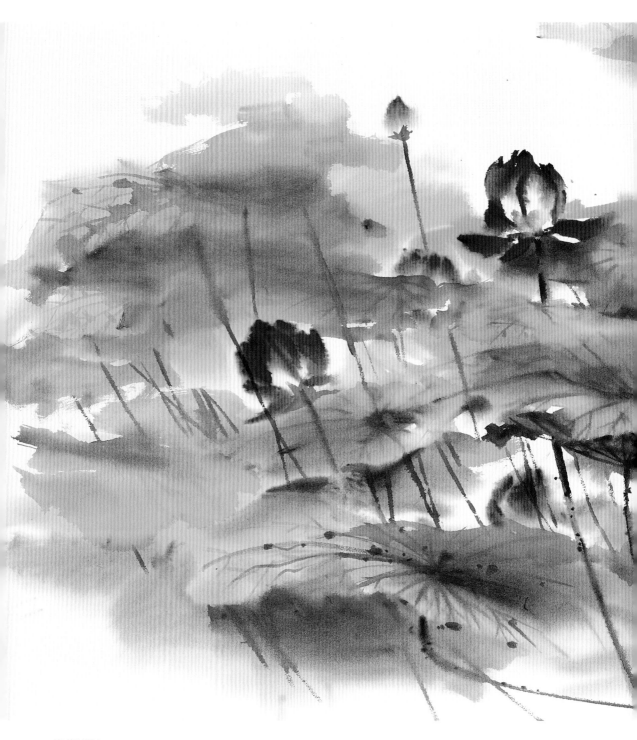

荷花滿塘

Boundless Lotus Pond
76×146cm 2013

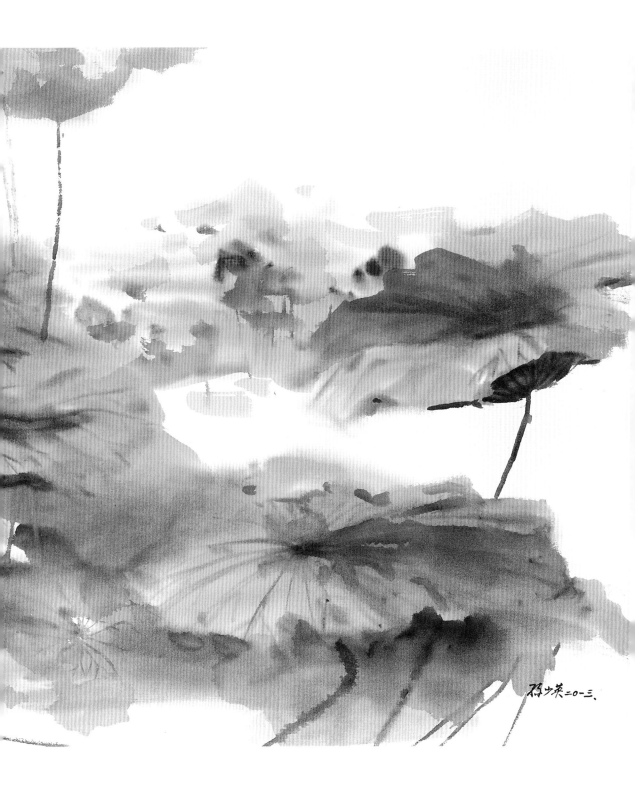

孫少英二0一三、

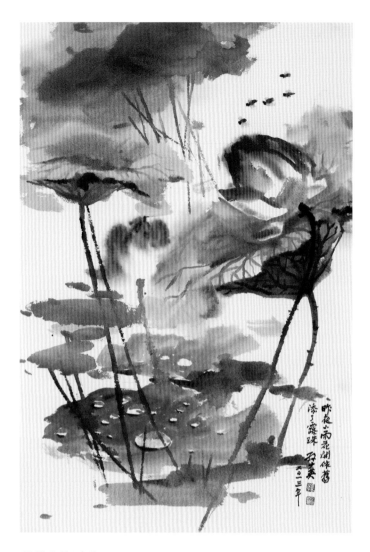

荷葉上的露珠

Dew Drop on the Lotus Leaf
57×39cm 2013

新荷

田田八九葉，攜手上雕航。

船移兮細浪，風散動浮香。

遊鶯無定曲，驚鳧有亂行。

蓮稀釧聲斷，水廣棹歌長。

棲鳥還密樹，泛流歸建章。

李群玉

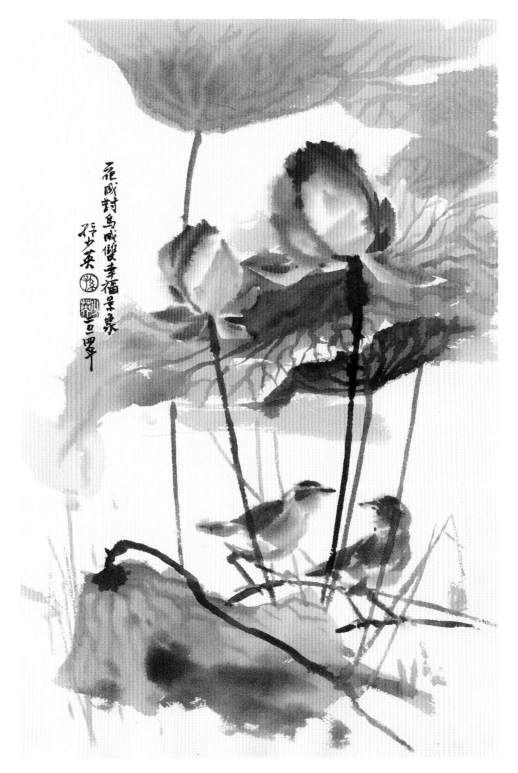

赤鸛鳥到來
Visiting
57×39cm 2014

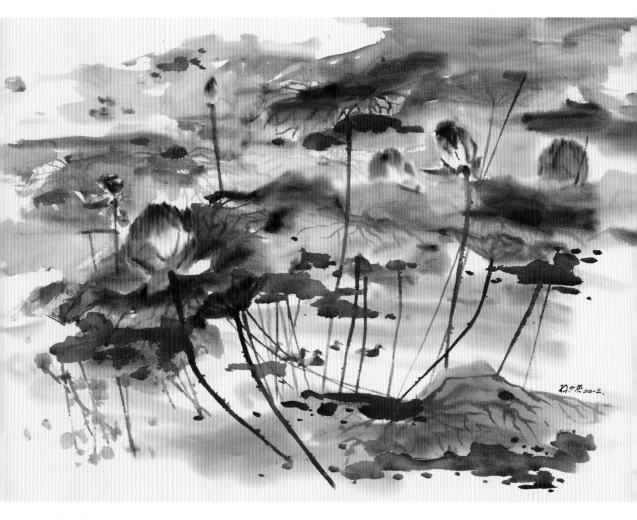

荷塘花開鴨嬉戲
Lotus Blooming, Duck Playing
79×110cm 2013

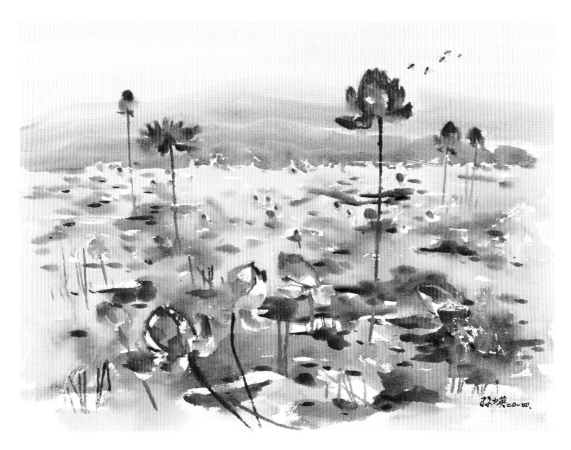

白河花田
Lotus Pond at Baihe
57×78cm 2014

我畫蘭花 ——————————————— 孫少英

蘭花有一萬多種，多彩多姿，是畫畫的上好題材。

我喜歡也常畫的蘭花有四種，分別是石斛蘭、蝴蝶蘭、萬代蘭和嘉德麗雅蘭。

國蘭以水墨畫較宜，蘭葉要靠書法功力，因爲色彩較少，所以我不常畫國蘭。

水彩畫有渲染、留白及彩度飽和的特殊性能，故畫蘭花或其他花種，應該是最優越的媒材。

我畫石斛蘭，是因爲太喜歡它細長帶節的花莖，多枝下垂，極有變化。密佈的氣根盤踞在蛇木上，交錯重疊，很有畫味。

蝴蝶蘭是萬種蘭花中最富麗的一種。

萬代蘭多養在特製的木架上，不需蛇木，更不需土壤，氣根特別發達，稍加施肥，鬚根會多如白色美髯。

嘉德麗雅蘭的花朵上生有多種色彩，繽紛多姿，畫者在色彩運用上可以充分發揮。

我畫蘭花的用具跟荷花完全一樣：

紙是ARCHES

顏料和筆是HOLBEIN

我習慣的畫法是：

紙先浸濕，濕畫會有滋潤感。

通常是先畫花朵，其他莖、葉、根、蛇木或花盆，完全以花爲基準，做適當之搭配。

花的乾濕用筆很重要，太乾會顯得拘泥呆板，太濕會弄得面目全非，在濕潤中畫出形狀，是最佳境界。

淺色的花要靠葉和莖來襯。彩度固然重要，明度對比更為重要，一張水彩畫明度把握好，自然會有明快愉悅的感覺。

獨立的白色花朵要靠背景來襯。例如白色的蝴蝶蘭，數十個花朵，不能都是花白，要選擇最向光的一朵，完全留白，其他要依次減弱，這樣畫，才會有層次感，有生命力。

很多人畫蘭花從不畫根，蘭花的氣根最漂亮了，一張蘭花畫作，花、莖、葉、根、蛇木、花盆、或是花架搭配得宜，黑白灰、點線面都有了，絕對是一幅好畫。

有一種蘭花叫瀑布蘭，其實是由很多株石斛蘭集結成的，密集的白色花朵下垂如瀑布，極為優美。這種蘭花最難畫，因為密密麻麻的花和葉，不可能一花一葉的全部細描，這要看各人用筆的靈巧工夫，該省略的要省略，選擇重要明顯的部位，把花、莖、葉凸顯出來。畫花要畫活，切勿畫死。

古人說，畫要拙，這不能一概而論，該拙的要拙，該靈巧的絕不能畫拙。

蘭花不好養，要悉心照顧。但有時候在牆的一角或是亂藤堆裡，不知什麼時候冒出了一兩支美麗的蘭花花朵，令人驚豔。碰到這種情形，我都會寫生下來，一方面是畫面很美，一方面是珍惜這份逆境生存的意境。

My Orchid Paintings Sun Shao-Ying

There are more than ten thousand orchid species. Their colorful variations are an excellent subject for painting.

My favorite orchid flowers that are frequently depicted are four kinds, including Dendrobium, Phalaenopsis, Vanda and Cattleya.

It is better to paint Cymbidium with ink. To depict orchid leaves requires the effect of calligraphy. I rarely paint it in watercolor, because it takes fewer colors.

Watercolor is specialized in the effects of rendering, white space and color saturation. So it should be the most excellent medium to paint orchids or other flowers.

I paint Dendrobium, because I extremely love its elongated, jointed flower stem. It is full of variations with its multiple droopy branches. And it is pictorially inviting as its aerial roots coil around snakewood ferns extensively and intricately.

Phalaenopsis, or Moth Orchid, is the most splendid kind among ten thousand orchid species.

Vanda is mostly breeding on a special wooden rack, requiring no snakewood ferns or soil. Its aerial roots are particularly flourishing, as bloomy as beautiful white whiskers if slightly fertilized.

There are multiple colors on the flower of Cattleya, variously mannered, so the painter can fully exploit the range of coloring.

The art supplies I choose to paint the orchid are exactly the same with those to paint the lotus.

I use Arches paper and Holbein pigments and brushes.

I have developed a habit of painting the orchid.

I first soak the paper in water, because painting on the wet paper increases the feeling of moisture.

I usually begin with painting flowers and coordinate other stems, leaves, roots, snakewood ferns or flower pot in proper arrangement completely based on the depicted flowers.

The dry-or-wet brushwork is very important for painting flowers. It becomes rigid and dull if the brushwork is too dry, while it becomes messy and formless if too wet. The perfection can only be achieved by shaping the form in proper moisture.

Light-color flowers depend on the support and contrast of leaves and stems. Chroma may be important, but brightness contrast is even more significant. A watercolor naturally appears lucid and cheerful with good control of brightness.

Independent white flowers rely on the contrast of the background. For example, white Phalaenopsis holds dozens of flowers, which cannot be simply depicted in gray. The one that is closest to the light has to be chosen to be in pure white space, while the others should be moderated in order. In this way, there will be a sense of gradation and then liveliness can be created.

A lot of people never depict the roots when painting the orchid. Yet, the aerial roots of the orchid are the most beautiful part. For an orchid painting, it requires the proper arrangement of flower, leaf, stem, root, snakewood fern and flower pot or rack, as well as black-white-gray and point-line-plane, to be perfect.

There is a kind of orchid, namely waterfall orchid, which is actually formed by many plants of Dendrobium. Its dense white flowers fall down like a waterfall, extremely elegant and beautiful. This kind of orchid is the most difficult to depict, because there are densely numerous flowers and leaves, which cannot possibly be completely portrayed in detail. Therefore, it depends on individual brushwork and craftsmanship to select the obviously essential parts and omit the unnecessary ones, in order to accentuate flowers, stems and leaves. Remember to paint flowers in vivacity, avoiding stiffness.

The ancients might have said that painting needs to be raw. But this rule may not be universally applied. It can be raw when necessary, but it should never be raw when ingenuity is called for.

It is not easy to breed the orchid, which requires scrupulous care. However, sometimes at a corner of a wall or amid a clutter of vines, one or two pretty orchid flowers are blooming unknowingly in surprise. Every time when I see this, I would always sketch it, because it is a very beautiful picture and also an invaluable reminder of survival in predicament.

花紅葉綠
Red Flower, Green Leaf
39×29cm 2014

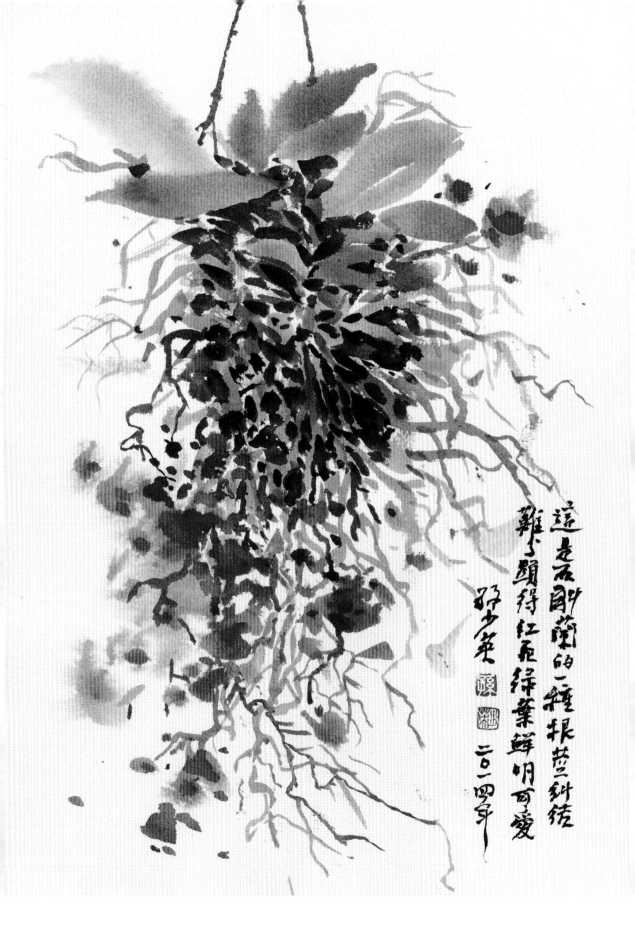

這是石斛蘭的一種根莖斜綴
難以顯得紅花綠葉鮮明可愛
孫少英 二○一四年

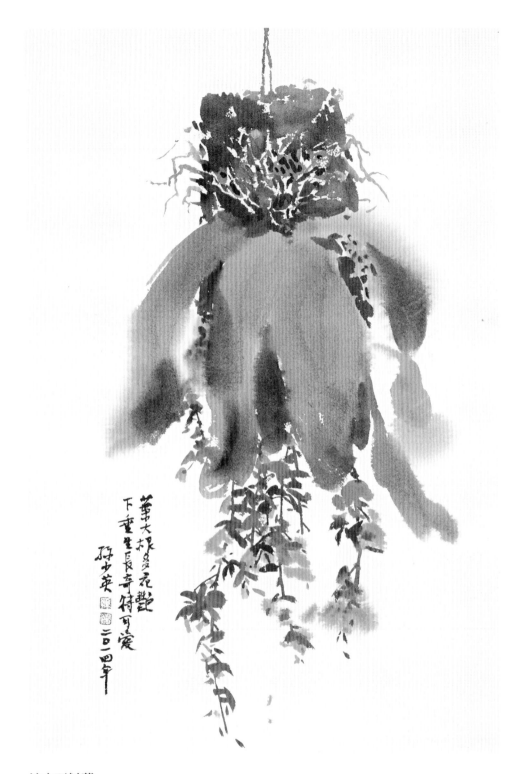

蛇木石斛蘭

Dendrobium

57×39cm 2014

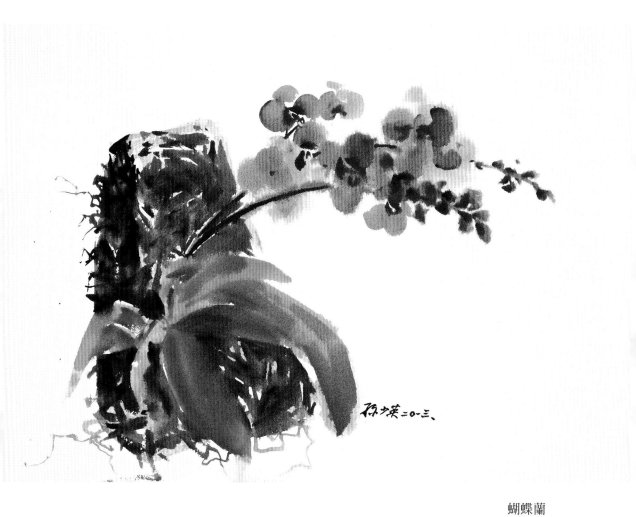

蝴蝶蘭
Phalaenopsis
39×57cm 2013

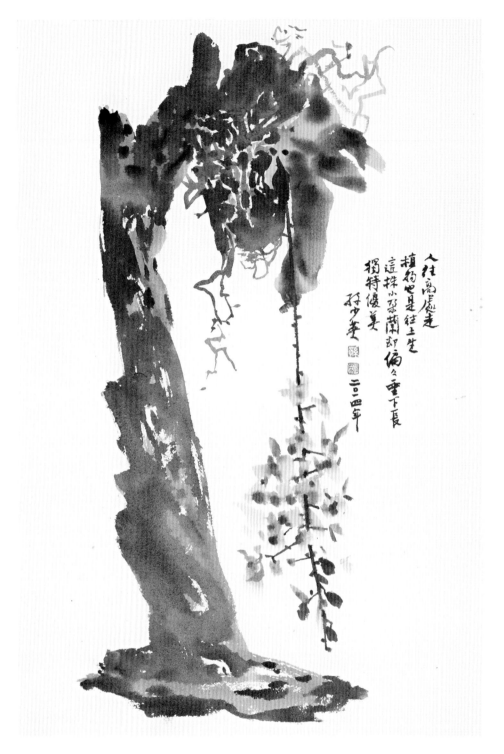

人往高處走
植物也是往上生
這採小棵蘭卽偏々要下長
獨特優美
林少華 [印] [印] 二○二四年

枯木養蘭

Orchid on Dead wood

57×39cm 2014

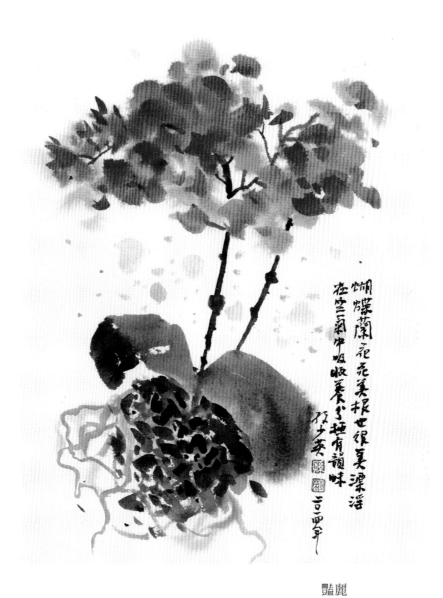

蝴蝶蘭花花美根也很美漂浮在空氣中吸收養分種有韻味 孔少英 二〇一四年

豔麗

Charming Phalaenopsis
39×29cm 2014

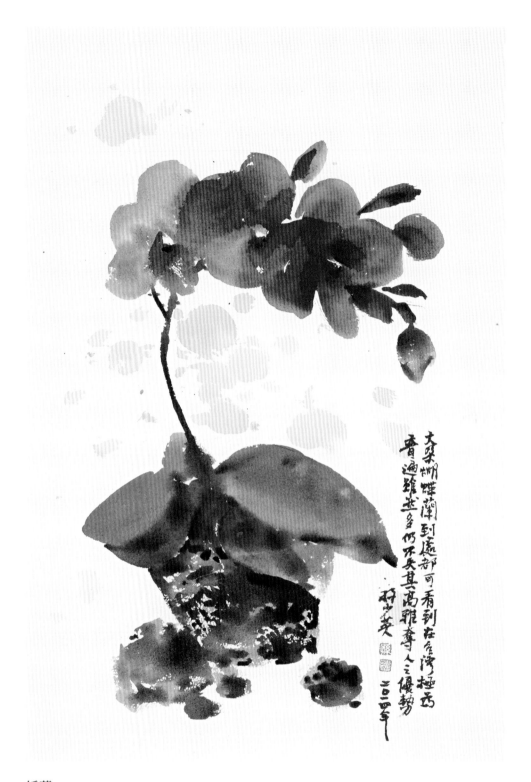

大朵蝴蝶蘭到處都可看到在台灣極西
晉遍雖然多仍不失其高雅尊人之優勢

林少英
二○一四年

嬌蘭
Dainty
57×39cm 2014

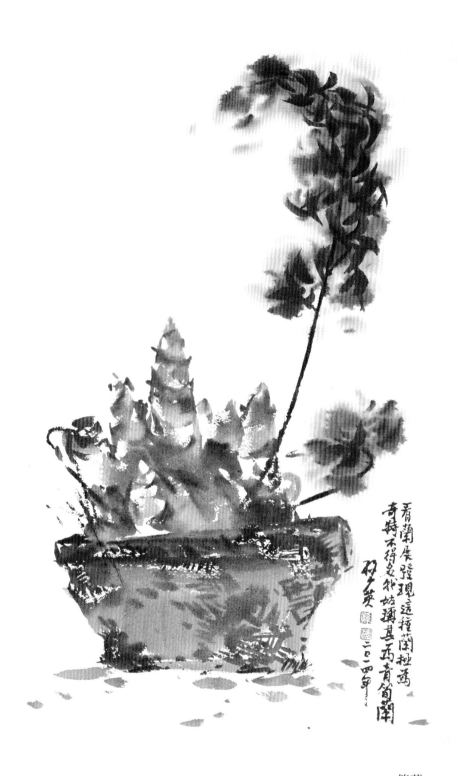

看蘭展發現這種蘭挺為
奇特不得其名姑擬甚名為青筍蘭
石虎 二〇一四年

筍蘭
Thunia
57×39cm 2014

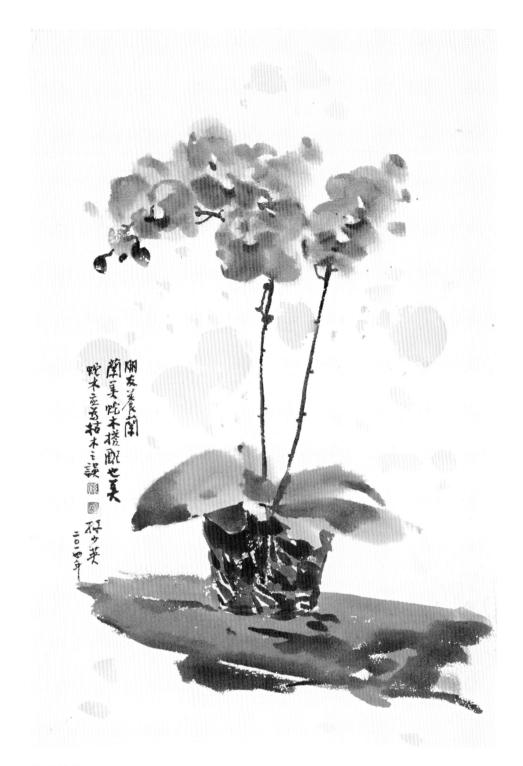

搭配枯木

Orchid and Dead wood

57×39cm 2014

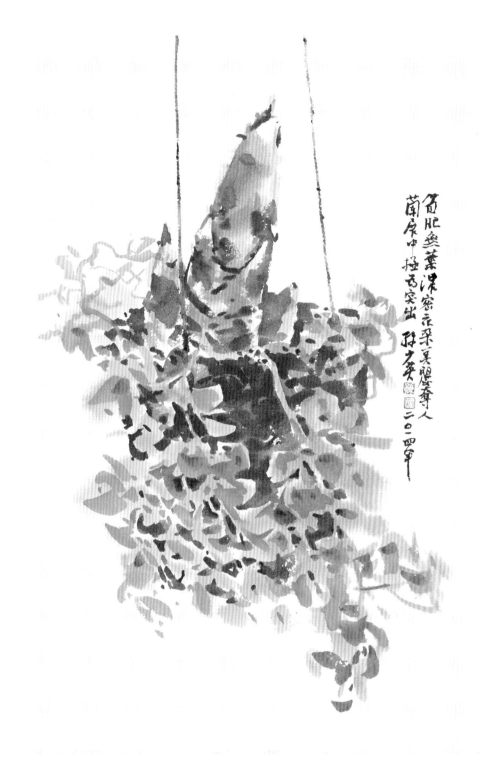

筍肥無葉漿濃密花采萋幽寥奪人
蘭展中挺高突出 孫九英 二〇一四年

橙花筍蘭
Orange Orchid
57×39cm 2014

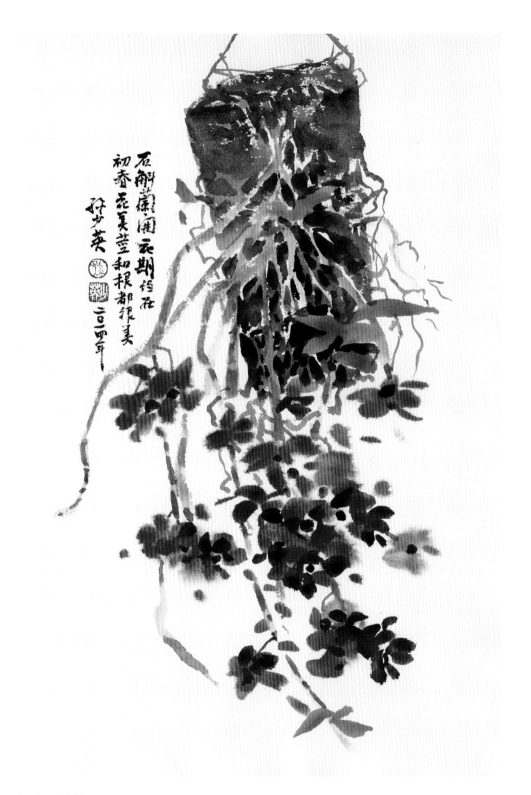

初春石斛蘭

Dendrobium in Early Spring
57×39cm 2014

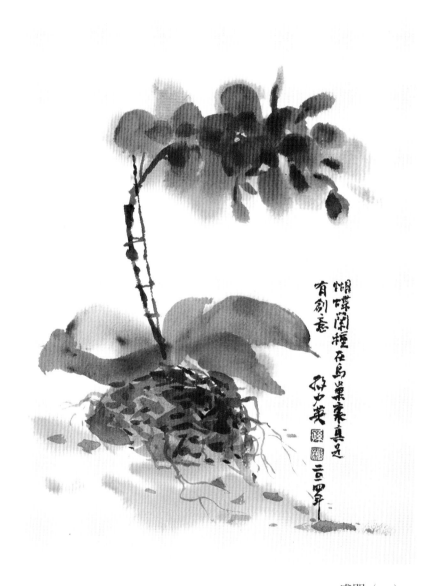

盛開（一）
Blossom (1)
39×29cm 2014

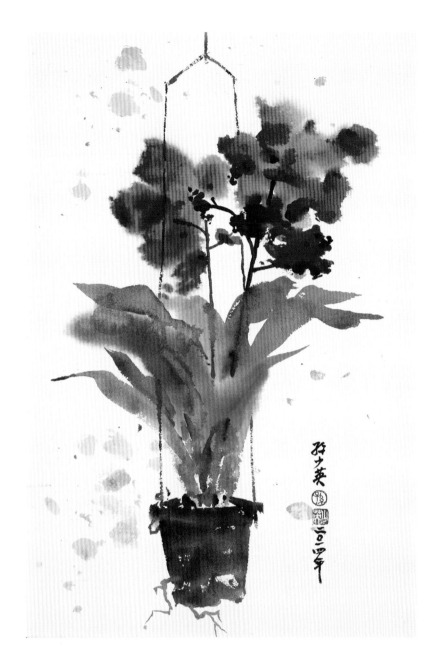

嘉德麗雅蘭
Cattleya
39×29cm 2014

壁上小蘭
Orchid on the Wall
57×39cm 2014

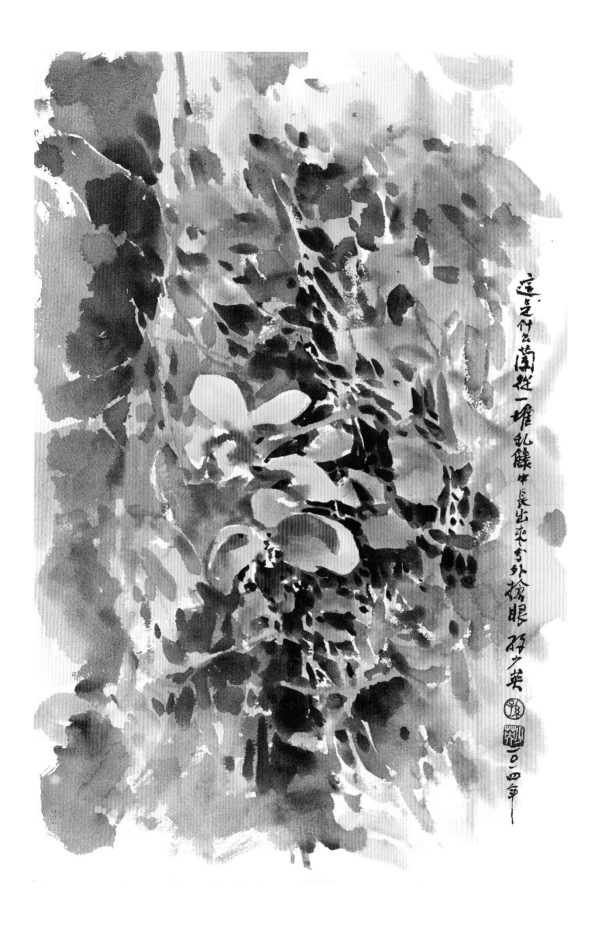

這是什么蘭挺一堆亂藤中長出來分外搶眼 孫文英 二〇一四年

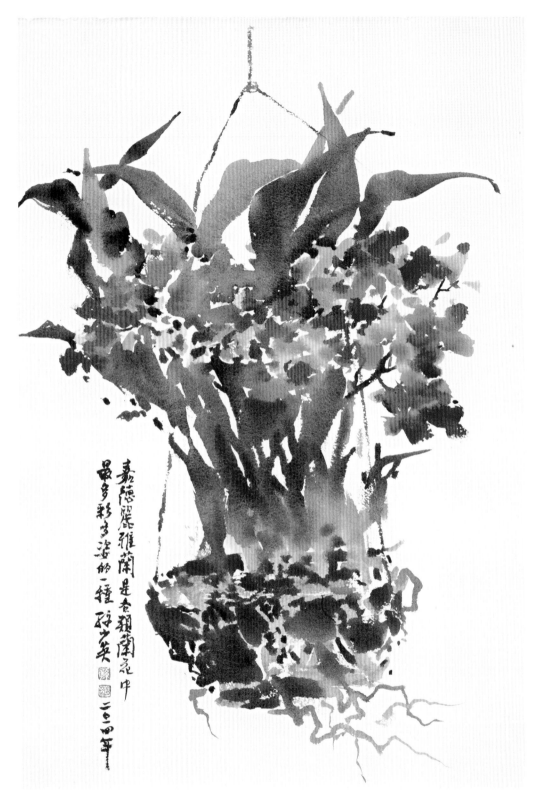

嘉德麗雅蘭是含類蘭花中最多彩多姿的一種　孫少英　二〇一四年

嘉德麗雅蘭

Cattleya
57×39cm 2014

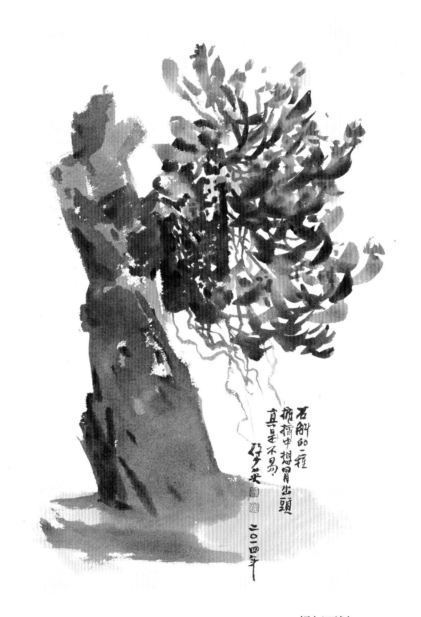

石斛的二種
攀摺中想胃出頭
真是不易
何少英畫禮
二○一四年

橘紅石斛
Tangerine Dendrobium
57×39cm 2014

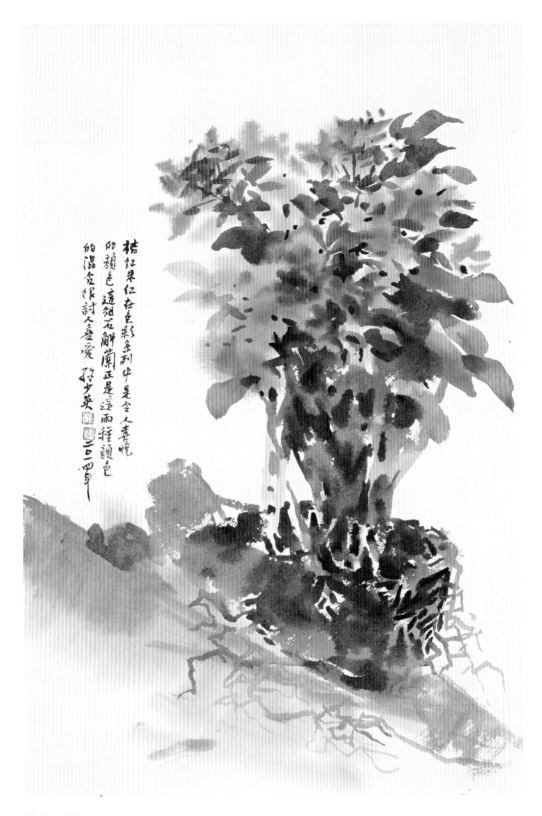

黃色石斛
Yellow Dendrobium
57×39cm 2014

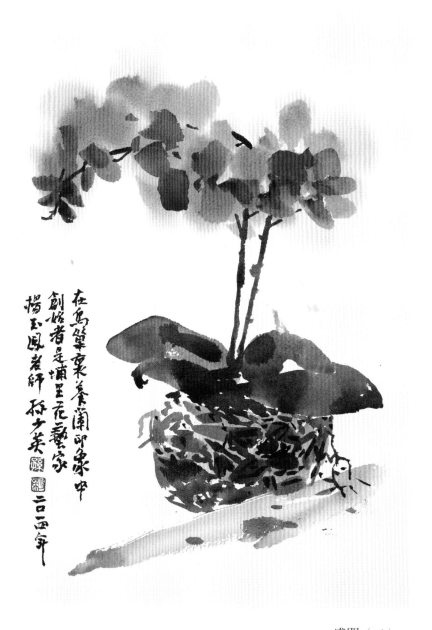

在烏篁裏養蘭印象中
創始者是埔里花藝家
楊玉鳳老師 林少英 二〇一四年

盛開（二）
Blossom (2)
39×29cm 2014

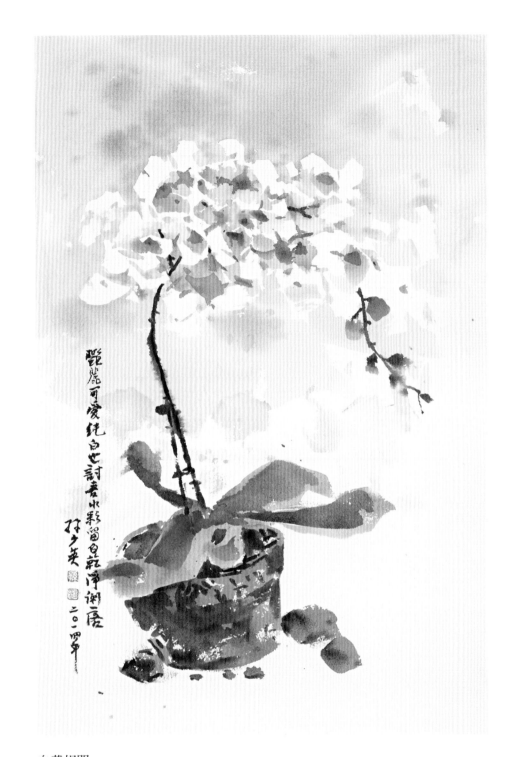

白黃相間

White and Yellow
57×39cm 2014

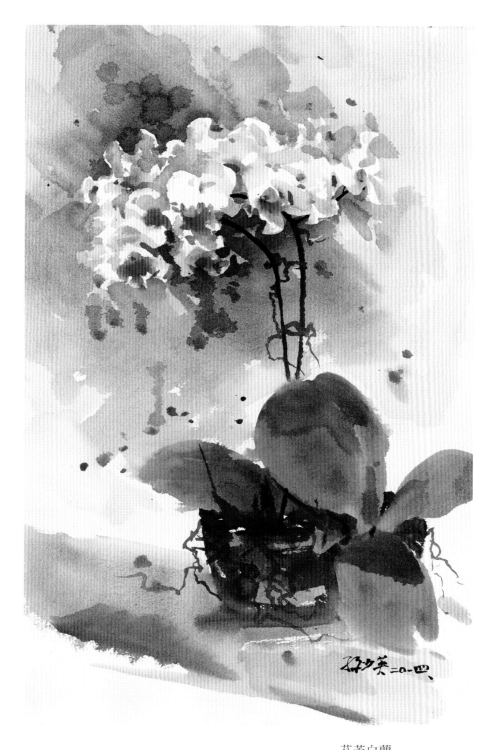

芬芳白蘭
White Fragrant Phalaenopsis
57×39cm 2014

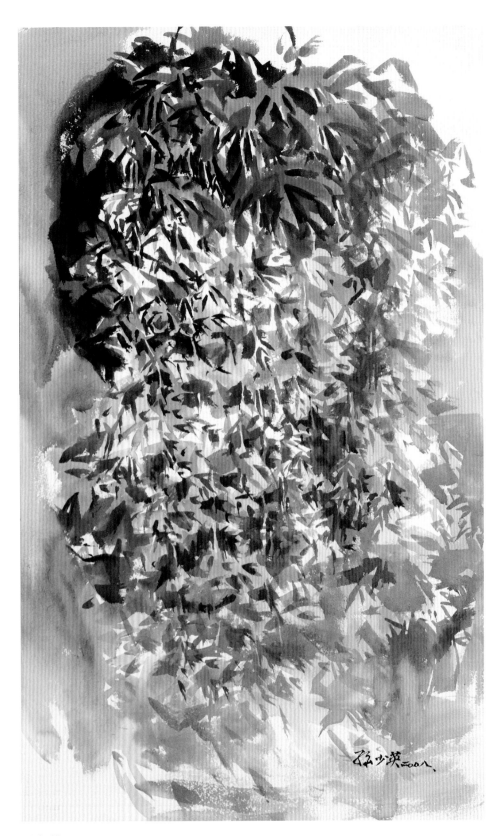

瀑布蘭
Waterfall Orchid
78×57cm 2008

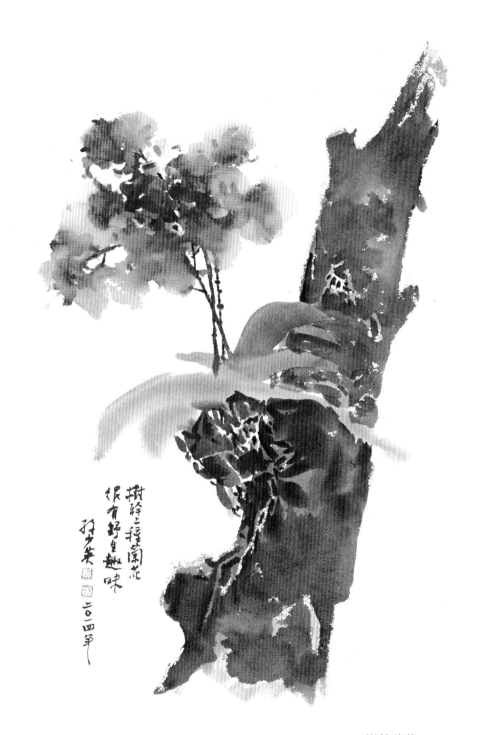

樹幹上種蘭花
很有野生趣味

樹幹養蘭
Orchid on the Tree
57×39cm 2014

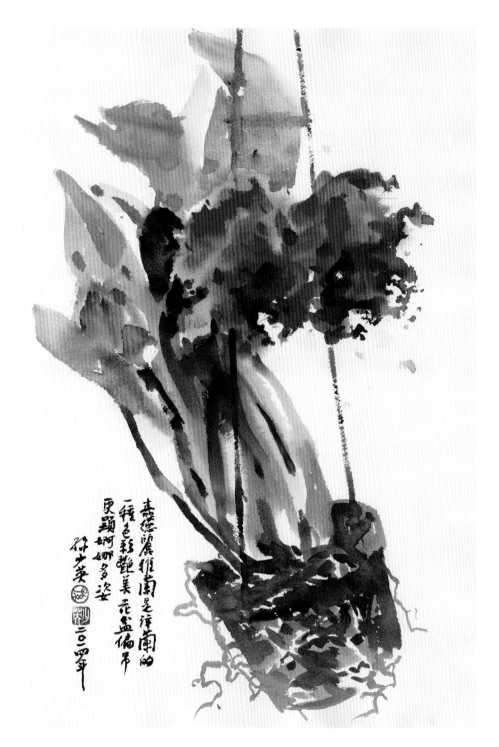

婀娜多姿
Orchid Melody
57×39cm 2014

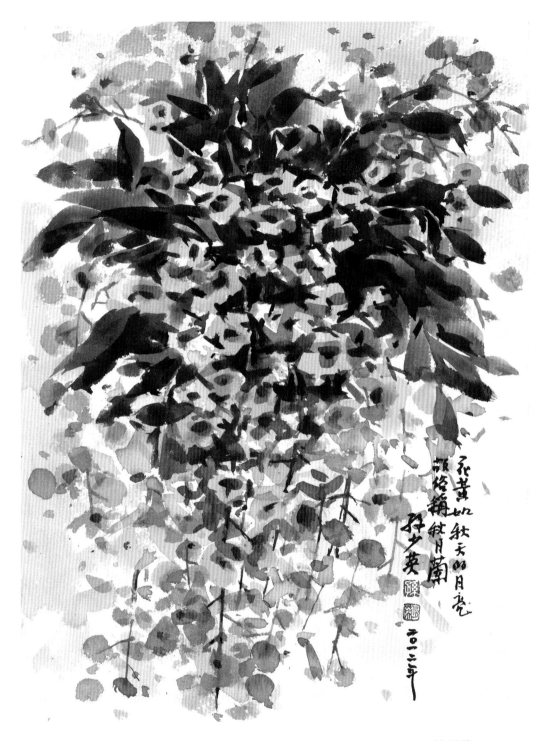

秋月蘭
Autum moon Orchid
39×29cm 2012

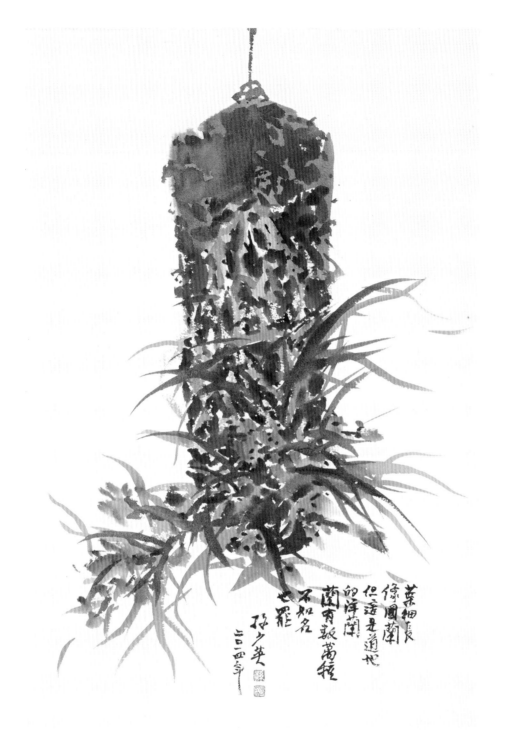

葉細長
像國蘭
但違是道地
的洋蘭
蘭有數萬種
不知名
也罷

孫少英
二〇一四年

蛇木石斛蘭
Dendrobium
57×39cm 2014

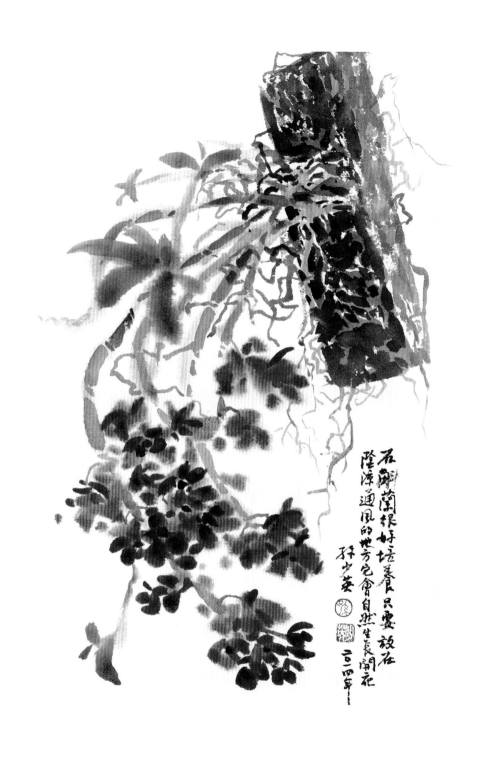

君如對蘭根好培養只要放在
陰涼通風的地方它會自然生長開花
孫少英
二〇二四年

初春石斛蘭
Dendrobium in Early Spring
57×39cm 2014

綻放 台灣色彩 _____ 盧安藝術執行長 康翠敏

　　農曆大年初一上午，我們一行三人打算給孫少英老師拜年去，一到孫宅沒想到一踏入庭園，老師老早在庭園中擺了一桌過年的糕餅糖果、白酒、烏龍，候著親朋好友來哪！

　　園中此時櫻花待開，紫藤花謝，我們就在櫻花樹下吃吃花生，喝喝小酒，聊聊去年畫展及寫生的二三事，說說家裡的芝麻綠豆事，忽然老師說：「翠敏啊！你最近有沒有看到有一位齊柏林先生拍了一系列＜看見台灣＞的空中攝影影片呀？..........」老師言談中對此片稱讚有加，對拍攝過程的艱辛與難處深有感觸，因為早期他在台灣電視公司工作，對攝影也頗為了解。老師說台灣真的很美，比起山東老家，那真是四季如春，鳥語花香的寶島呀！這也是為什麼他在1991年自台視退休以後，會想到台灣各地寫生的動力，他的彩筆畫阿里山、日月潭，畫完了大景點，又畫台灣小鎮和離島，這些景色在寫生中帶給孫老師的悸動，張張化為色彩豐富，蘊染豐潤的水彩畫作，稱得上是代表台灣色彩的最佳呈現。

　　老師突然間話鋒一轉說道：「那好，不如接下來我們就以〝台灣色彩〞為主題來計畫新年度的方向吧！」接著孫師母又為我們備上水梨和蘋果，孫老師又說老家有的是水梨蘋果，但是就沒有像台灣花卉這麼多彩多姿，尤其在色彩上，記憶中的山東冬天一到就是一片枯黃，哪像這裡色彩這麼豐富美麗！

　　環顧庭園四周的花木扶疏，紫藤棚下吊著一盆一盆的蘭花，旁有睡蓮池，側有桂花樹，牆圍旁一列野薑花，入口處又有櫻花，孫老師的庭園就如他作畫風格簡潔中有底蘊，明快中有層次，有時寫生不需捨近求遠，就在門廊下，池塘邊完成畫作，隨著季節變化，春石斛秋桂花，輕鬆捕捉台灣季節色彩甚是便利。

　　難怪老師的水彩畫作中，除了台灣各地風光，花卉的描繪作品也經常可見。尤其是荷花和蘭花的畫作年年都有。荷花的「出淤泥而不染」，自古以來即是文人墨客最愛的主題；再提到蘭花，在台灣有豐富的蘭花品系,如蝴蝶蘭、石斛蘭、文心蘭等等，四季都有美蘭可入畫，談到台灣代表性花卉非蘭花莫屬。

　　所以就在新春閒話家常的談話中，老師想以水彩來展現荷花的清麗風格和蘭花的高雅氣韻，善用水彩的水性和潤性，和他特有的「西畫中韻」的畫風，蘊染出花卉自由綻放的台灣色彩，於是老師就為《荷風蘭韻》畫冊定調了。

Blooming Colors of Taiwan _____ Skang Tsui-Min CEO, Luan Ture Art

On the morning of the first day of the Lunar Chinese New Year, we, a group of three, intended to visit Master Sun to give New Year's greetings. And as we stepped into the garden of Sun's house, we were surprised to find that Master had already set up a table with New Year's treats and sweets, white spirit and oolong tea, waiting for the visit of relatives and friends.

At that time, cherry flowers in the garden were blossoming but purple vines were withering away. So we sat under the cherry tree, eating peanuts and drinking, and chatted about art exhibitions and nature painting from the previous year, as well as petty household affairs. Suddenly Master said, "Tsui-Ming, have you seen recently a series of aerial-photography films by Mr. Chi Po-lin such as Beyond Beauty: Taiwan from Above?" Master spoke highly of this film and deeply sympathized with the hardship and difficulty during the filming, because he had worked at Taiwan Television in early days and knows about photography. He said that Taiwan is truly very beautiful, a real treasure island that is like spring all the year round full of singing birds and blossoms, as compared to his hometown, Shandong. That is why he had been prompted to paint from nature all over Taiwan after his retirement from Taiwan Television in 1991. His color brushes have painted Alishan and Sun Moon Lake. In addition to big scenic spots, he has continued to paint Taiwan's small towns and off-shore islands. The sensation of these scenes that had inspired Master Sun during his nature painting has been turned into watercolor works with abundant colors and saturated rendering. They can be qualified as the best representation of Taiwan's colors.

Unexpectedly, Master switched the topic and said that "Well then, let's take colors of Taiwan as the subject of our next annual project." And then Mrs. Sun served us with pears and apples, while Master said that his hometown is prolific in pears and apples, but lacks various colorful flowers as seen in Taiwan. And particularly in terms of color, he remembered that in winter, Shandong is all withered and yellow, unlike Taiwan that is full of beautiful and bountiful colors.

As we looked around the garden in bloom, there were orchid flowers hanging under the purple-vine shed, neighbored with a water-lily pond and osmanthus trees. And there was a line of ginger lily along the wall and cherry blossoms at the entrance. Master Sun's garden is just like his painting style, profound yet simple and lucid yet gradational. Sometimes, he doesn't need to go very far to paint. As conveniently as under his doorway o by the pond, he could easily capture the changeable seasonal colors of Taiwan and finish a painting, such as Dendrobium in spring and osmanthus in autumn.

No wonder that in addition to Taiwan scenery, floral depiction also frequently appears in Master's watercolor works. Especially the lotus and orchid paintings are created every year. The lotus grows out of the mud but blossoms purely, and therefore it has always been the favorite subject for the literati and refined artists since the ancient time. Speaking of the orchid, Taiwan is prolific in orchid species, such as Phalaenopsis Dendrobium, Oncidium, etc. In four seasons, there are always beautiful orchid flowers that can be painted. The orchid is indeed the representative flower of Taiwan.

Thus, during the chitchat of the Chinese New Year, Master set the tone for his album, *Lotus Breeze · Orchid Melody*. He has intended to demonstrate the pure beauty of the lotus and elegant manner of the orchid by watercolor, combining the sense of moisture and saturation in watercolor qualities with his special style of Chinese temperament in western paintings, in order to render the colors of Taiwan from freely blooming flowers.

國家圖書館出版品預行編目資料

荷風蘭韻 / 孫少英作. -- 臺中市：盧安藝術文
化, 民103.10
120面；18×26公分
ISBN 978-986-89268-2-0（平裝）

1.水彩畫　2.畫冊

948.4　　　　　　　　　　103018249

Lotus Breeze
Orchid Melody

作　　者：孫少英

發 行 人：盧錫民

總 策 劃：康翠敏

英文翻譯：李若薇

英文校對：朱侃如

文字校對：廖英君　蕭芮琦

出版單位：盧安藝術文化有限公司

郵政劃撥帳號：22764217

地　　址：403台中市西區台灣大道2段375號11樓之2

電　　話：04-23263928

E-mail：luantrueart@gmail.com

官　　網：www.luan.com.tw

設計印刷：立夏文化事業有限公司

地　　址：412台中市大里區三興街1號

電　　話：04-24065020

出　　版：中華民國103年10月

定　　價：新臺幣1000元

ISBN　978-986-89268-2-0